FROM THE FILMS OF

Harry Potter | Fantastic Beasts

THE WANDS OF THE WIZARDING WORLD

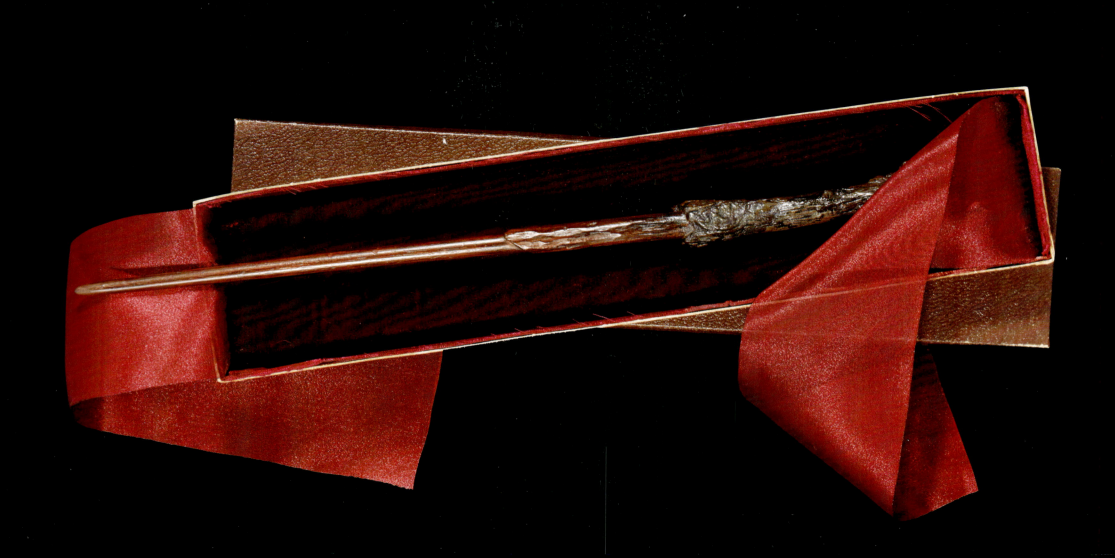

FROM THE FILMS OF

Harry Potter | Fantastic Beasts

THE WANDS OF THE WIZARDING WORLD

MONIQUE PETERSON • JODY REVENSON

SAN RAFAEL · LOS ANGELES · LONDON

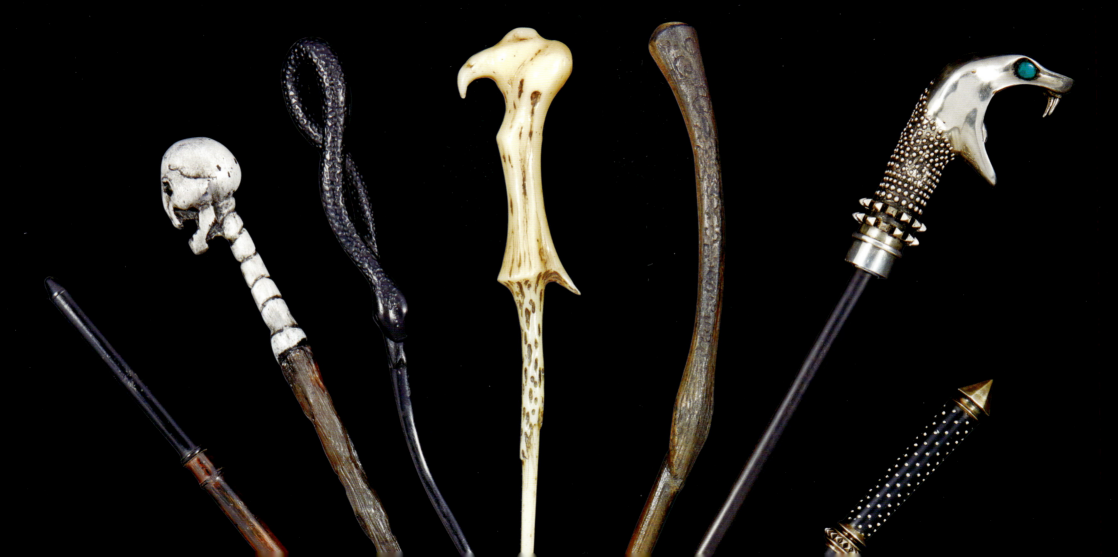

CONTENTS

Introduction 6
What Is a Wand? 8
The Wandmakers 10
Wand Selection 16
Wand Movements and Technique .. 18
Wand Battles 20

THE WANDS

Hogwarts Students
Harry Potter 28
Ron Weasley 30
Hermione Granger 32
Neville Longbottom 34
Fred Weasley 36
George Weasley 38
Ginny Weasley 40
Draco Malfoy 42
Luna Lovegood 44
Dean Thomas 46
Seamus Finnigan 48
Vincent Crabbe 50
Gregory Goyle 52
Cho Chang 54
Parvati Patil 56
Padma Patil 58
Cormac McLaggen 60
Katie Bell 62
Lavender Brown 64

Hogwarts Professors and Staff
Professor Dumbledore 66
Professor McGonagall 68
Professor Snape 70
Rubeus Hagrid 72
Professor Sprout 76
Madam Pomfrey 78
Professor Flitwick 80
Madam Hooch 82
Professor Lockhart 84
Professor Lupin 86
Professor Moody 88
Professor Umbridge 90
Professor Slughorn 92
Professor Trelawney 94

The Triwizard Tournament
Cedric Diggory 96
Fleur Delacour 98
Viktor Krum 100

The Order of the Phoenix
Sirius Black 102
Nymphadora Tonks 104
Kingsley Shacklebolt 106
Mundungus Fletcher 108
Molly Weasley 110
Arthur Weasley 112

Noteworthy Wizards
Garrick Ollivander 114
Xenophilius Lovegood 116
Newt Scamander 118
Bunty Broadacre 120
Professor Hicks 122
Aberforth Dumbledore 124
Nicolas Flamel 126
Yusuf Kama 128

Dark Forces
Vinda Rosier 130
Credence Barebone 132
Lord Voldemort 134
Bellatrix Lestrange 136
Peter Pettigrew 138
Fenrir Greyback 140
Antonin Dolohov 142
Lucius Malfoy 144
Narcissa Malfoy 148
Alecto Carrow 150
Amycus Carrow 152
Corban Yaxley 154
Scabior 156

Wizarding Ministries
Ministry of Magic
Cornelius Fudge 158
Rufus Scrimgeour 160
Pius Thicknesse 162
Theseus Scamander 164
Leta Lestrange 166
MACUSA
Tina Goldstein 168
Queenie Goldstein 170
Percival Graves 172
Seraphina Picquery 174
International Confederation of Wizards
Anton Vogel 176
Liu Tao 178
Vincência Santos 180
Henrietta Fischer 182

A Muggle's Wand
Jacob Kowalski 184

The Elder Wand 186

Conclusion 189
Wand Index 190

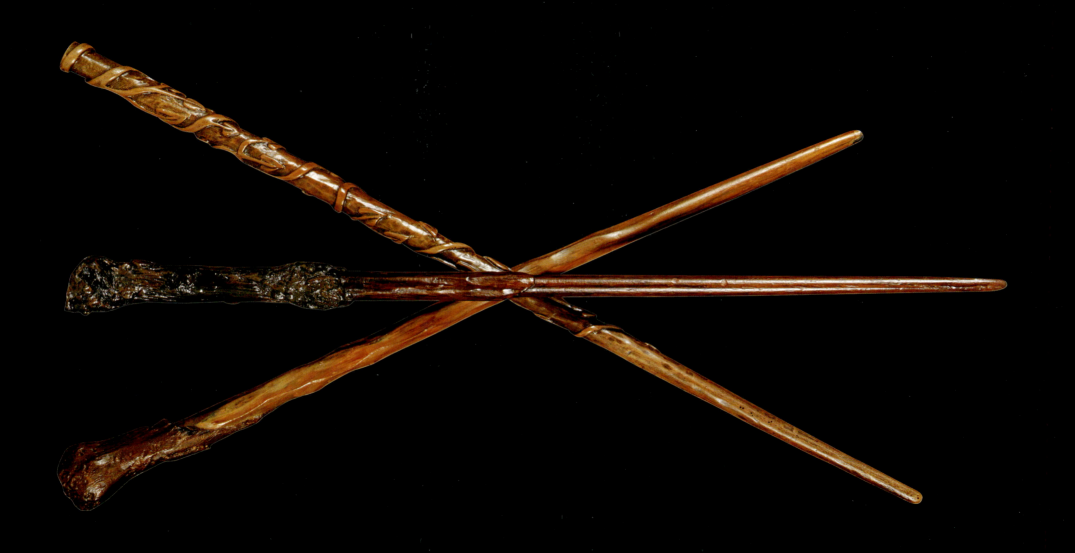

Introduction

In the world of magic, a witch or a wizard is incomplete without a wand. It is more than a tool; it is a force, an extension of intent. It embodies the very character of its holder.

In the wizarding world, wandmakers have been fine-tuning these handcrafted instruments of magic for more than two thousand years.

Harry Potter: The Wands of the Wizarding World takes a closer look at these magical wands, their makers, their masters, their powers, and their legends. From the filmmakers who designed and crafted them to the actors and characters who wield them, all have played a part in making the wands come to life on-screen.

Every wand has a story of its own.

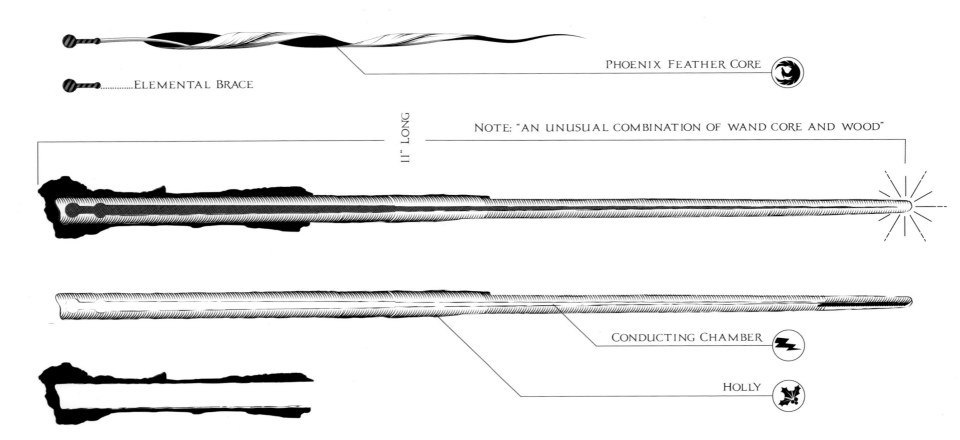

WHAT IS A WAND?

"You talk about wands as if they have feelings."

—Harry Potter to Ollivander, *Harry Potter and the Deathly Hallows – Part 2*

In the wizarding world, a wand is a device that allows its holder to channel their magical powers for greater, or at least more complicated, effects. As with many acts of magic, the art of crafting a magic wand requires certain materials and rituals.

When creating a wand, special attention is paid to selecting a core. Wandmakers choose something from a magical creature, such as the feather of a phoenix or the hair of a unicorn.

The core is then inserted into wood, such as willow, ash, yew, or holly. The specific material used to create a wand is important. Certain woods have unique characteristics, all of which are taken into consideration when selecting the material for a particular witch or wizard.

Length and flexibility are among the features that help define a wand as well as the character of its master. When Ollivander handles a pair of wands at Shell Cottage in *Harry Potter and the Deathly Hallows – Part 2*, he is able to accurately identify the wood, core, and owner of each one. The adjectives he uses to describe these wands could just as well apply to their masters: Draco Malfoy's wand is "reasonably pliant," while Bellatrix Lestrange's is "unyielding."

The most powerful wand in the wizarding world is the Elder Wand. According to "The Tale of the Three Brothers" in *The Tales of Beedle the Bard*, when a wizard outwits Death, he asks for the most powerful wand in existence as his reward. Death fashions him one out of an elder tree.

The Elder Wand was for many years in the possession of Gellert Grindelwald before he lost it to Albus Dumbledore. After Dumbledore's death, the Dark Lord Voldemort takes the wand from his tomb, but is never its true master.

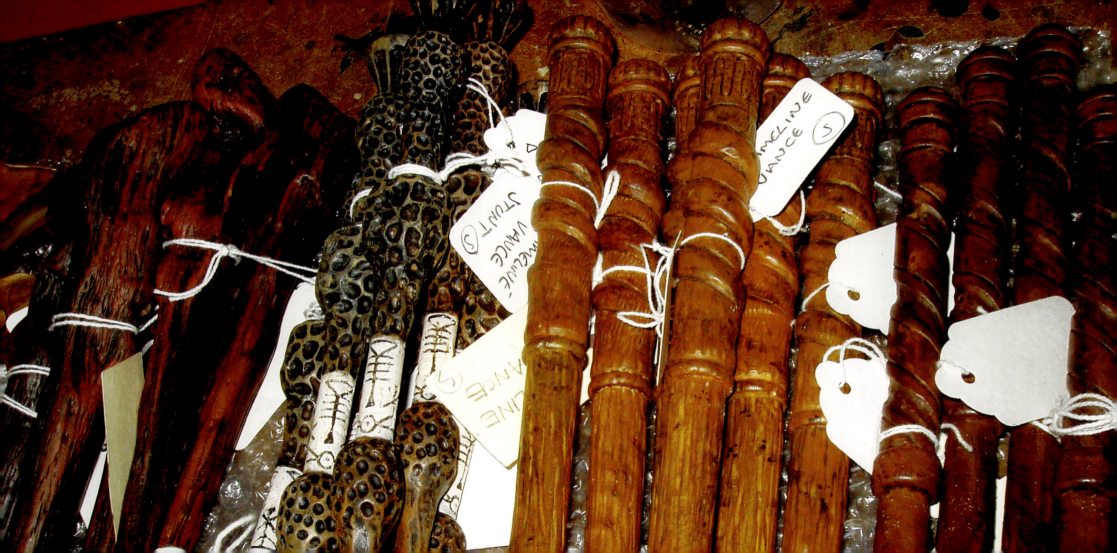

THE WANDMAKERS

"That wand needs replacing, Mr. Weasley."
—Professor McGonagall, Harry Potter and the Prisoner of Azkaban

Ollivanders is an age-old wizarding household name. They are known to be the creators of some of the finest wands, including Harry Potter's and Lord Voldemort's. Each wand is handcrafted from core to finish, from handle to tip.

For the wandmakers of the Harry Potter films, the design and modeling for each wand evolved from a host of creative minds, each bringing a unique aspect to the finished product.

The design process began with Diagon Alley, where Hogwarts students acquire all the basic equipment necessary for practicing witchcraft and wizardry, such as wands, brooms, books, cauldrons, and the like. Diagon Alley was one of the first sets the filmmakers built for Harry Potter and the Sorcerer's Stone. Director Chris Columbus wanted the place to feel as though it had been there for hundreds of years, "but as if it would go on forever." Ollivanders wand shop certainly has that feel, with thousands upon thousands of wand boxes stacked from floor to ceiling.

To create the individual wands, the artists studied the characters that J. K. Rowling created for the books, tapping into their unique qualities or peculiarities. For example, Lucius Malfoy, a distinguished wizard of wealth and a Death Eater, bears a wand of glossy ebony. Molly Weasley, mother of seven, carries a well-used plain hardwood wand that is simple and practical, and looks as if it may quite possibly be made of recycled wood.

Art director Hattie Storey describes her job as "all wands and broomsticks." Her team of artists drafted wand blueprints, outlining the length, material, detailing, and additional inlays or crafting. It is unusual for a film to have an art director dedicated specifically to props, but the sheer volume of such items that needed to be designed from scratch was so vast the

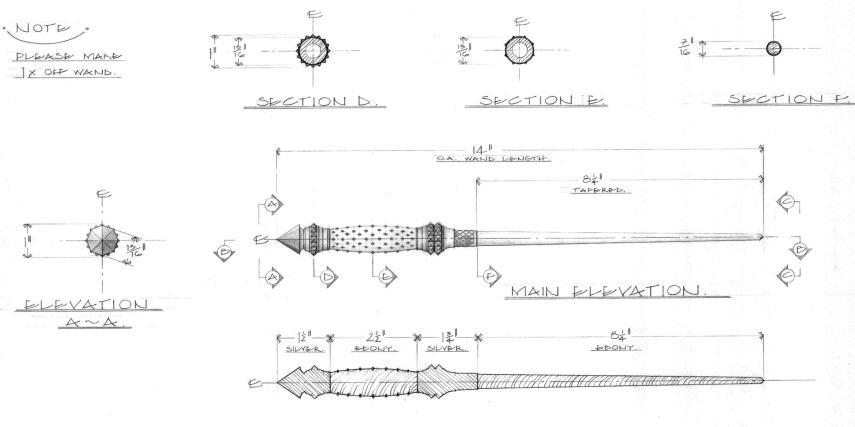

position continued throughout the entire series of Harry Potter films.

From the design to the drawing to the fabricating of the prop and stunt wands, every wand saw multiple stages of development. Property master Barry Wilkinson, prop modeler Pierre Bohanna, and concept artists Adam Brockbank, Alex Walker, and Ben Dennett, among others, all contributed to the process. The level of detail and thoughtful design is evident from the most powerful wand in the wizarding world, the Elder Wand, to the sweetest—the Licorice Wands for sale in Honeydukes sweet shop.

Once the filmmakers tailored the look of each wand, supervising modeler Bohanna was tasked with creating the original, from which duplicate wands would be made for use on set. This led to the search for appropriate source materials. "We looked for interesting pieces of rare wood with burrs and interesting shapes," says Bohanna. The team would then fashion molds from the specimens and make replicas out of resin and rubber to use for replacements and stunt work.

"Actual wood wands would be dangerous to use," says Bohanna. "If they fell, they'd split and shatter. Wood by its nature would be affected by heat, humidity, and cold. And it can bend, buckle, or break. So it's not a practical material to use day to day."

As the Fantastic Beasts films were set in an earlier time period than the Harry Potter films, and allowed a broader look into the wizarding world, from Paris to New York, the wandmakers expanded their design tools to include the styles and settings of the late 1920s and '30s and their locations. "*Fantastic Beasts and Where to Find Them*, where you have that booming New York City, there's a lot of Art Deco," says Bohanna. "*Fantastic Beasts: The Crimes of Grindelwald* was set in Paris near the end of the art nouveau period. That had a great influence on design."

But, as always, "wands are very bespoke to the character," Bohanna continues. "They want to reflect the character, and not just the character's character, but also their taste and their influence, and that comes down to style, which also comes down to fashion. So, to take that principle and put it into a certain time period, is actually almost liberating. It offers an inspiring set of rules for the designers to work with, interpret, and riff off. It's that question: What would a wand from 1926 look like? Of

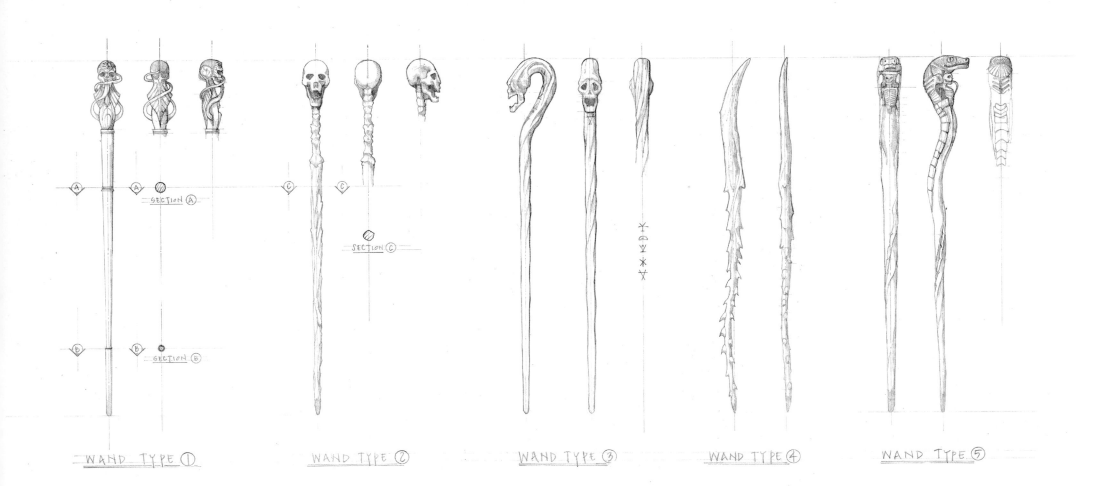

course, there's no example," he laughs. "So, you've got to think about it and make it up, and that's fantastic."

Junior concept designer Molly Sole, who began as a draughtsman on *Harry Potter and the Deathly Hallows – Part 1* and *Part 2* and then designed wands for the wizards in the Fantastic Beasts films, reiterates that the wand chooses the wizard: "You have to find out what makes that character tick. Then, [you] design the wand as if it was going to match or complement that character. For example, Queenie Goldstein is a Legilimens. She has the power to read minds, and you would imagine that the core of her wand might aid her in that magical ability. There has to be an affinity so that the wand can be utilized to the best of its ability." Sole even projects herself into the artifact, not just the character. "I feel as if I were a wand, I'd be trying to find a wizard who could use me to the best of any purpose," she says.

The actors themselves also give input into their character's wand. "I know Eddie Redmayne worked very much [on his wand] and was the final sign-off on its concept," says Bohanna. Prototype wands that match the concept are created at the start before a master is made and replicated. "But there's always two or three versions of it that will go in front of the actors," he continues. "And then we'll get their opinion. They may want a different or darker wood, or maybe a different design element."

Bohanna may not have been wand-making for as long as the Ollivander family, but he shares a similar passion for the craft. He says, "We never want to be doing the same thing twice, so we look at new materials and processes. If we don't know how to do something, or how to replicate something we like, then we find out." For Bohanna, "The most wonderful thing is that every wand we make is a voyage of discovery."

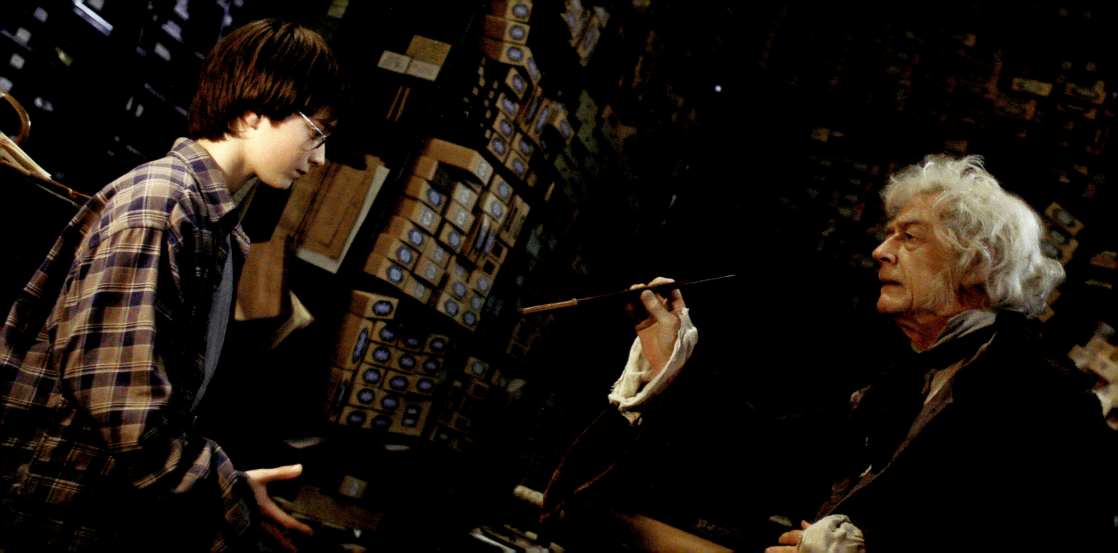

WAND SELECTION

"The wand chooses the wizard, Mr. Potter. It's not always clear why."

—Ollivander, *Harry Potter and the Sorcerer's Stone*

Garrick Ollivander of Ollivanders wand shop in Diagon Alley is widely considered the finest wandmaker in the world. It is a reputation well deserved, considering Ollivanders has been in business since 382 BC. When it comes time to get your wand, as Hagrid tells Harry Potter in *Harry Potter and the Sorcerer's Stone*, "Ain't no place better."

When Harry enters Ollivander's shop, he doesn't know what to do with the first wand he's handed. He holds it until the wandmaker prompts him to "give it a wave." Harry does, and scores of wand boxes fly out of their drawers, emptying their contents onto the floor. "Apparently not," Ollivander concedes. Harry's second wand manages to shatter a flower vase, sending glass fragments everywhere. This prompts Ollivander to select a wand with a very peculiar quality . . .

When Harry raises this wand, he lights up with a glow as the force of the magic surges through him. "Curious, very curious," Ollivander muses, for the wand bears the tail feather of a phoenix who has given just one other feather for another wand—the very wand responsible for the lightning-shaped scar on Harry's forehead.

Some seventeen thousand wand boxes lined the shelves of the Ollivanders set in Diagon Alley. Affixed onto each box was a label with wand information, including type of wood, core, and length, handwritten by the members of the graphics department. The detailing was made to look like runes, scripts, and alphabets from other cultures and times. Prop artists aged the boxes with a sprinkling of dust to give them their essence of antiquity. As a result, some wands look as if they have been waiting a very long time to find their rightful witch or wizard.

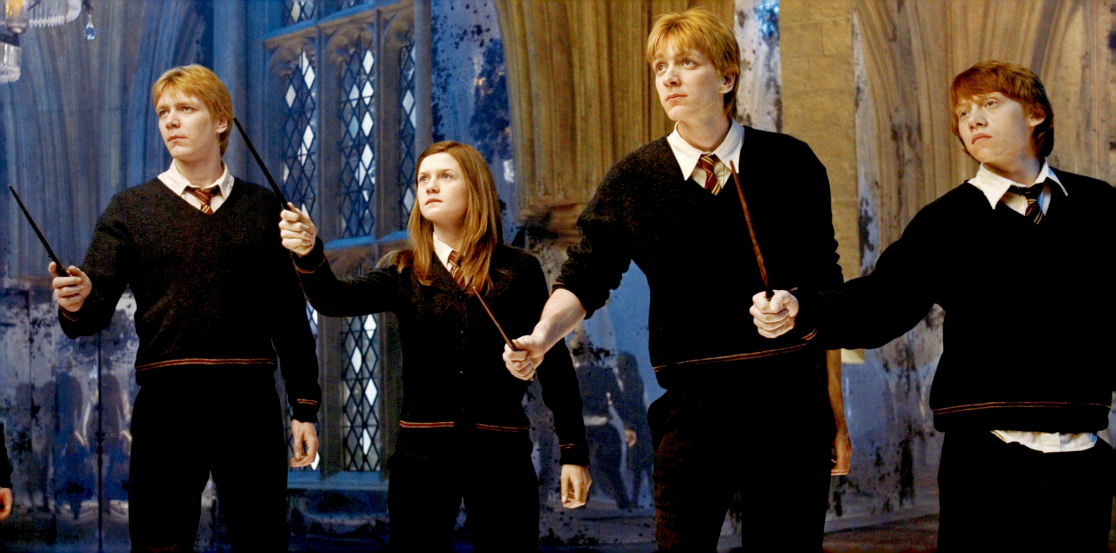

WAND MOVEMENTS AND TECHNIQUE

"Now, don't forget the nice wrist movement we've been practicing. The swish and flick."
—Professor Flitwick, *Harry Potter and the Sorcerer's Stone*

Lessons are essential for every witch or wizard who wishes to attain mastery of their instrument. As Hogwarts students learn in Professor Flitwick's Charms class, it takes a very precise "swish and flick" while reciting *Wingardium Leviosa* to make something levitate. Advanced students learn to master more particular movements to go with specific spells, such as the clockwise spin for *Reparo* or the hard right-angle flick for *Expelliarmus*.

David Yates, the director for *Harry Potter and the Order of the Phoenix* through *Harry Potter and the Deathly Hallows – Part 2*, wanted to make a distinction between how spells are performed by advanced wizards and by young novices. For *Order of the Phoenix*, actor Daniel Radcliffe, who plays Harry Potter, underwent movement classes to train in how to use the wand and master a particular choreography and "architecture" in terms of how to perform spells, which he admits he found quite hard at first—but really fun to do.

When Dolores Umbridge refuses to teach proper wand usage in her Defense Against the Dark Arts class in *Order of the Phoenix*, students enlist Harry, who has come face-to-face with Lord Voldemort, to teach them what he knows. They line up for practical lessons in the Room of Requirement, where Harry gets into the nuances of wand work. He shows Neville Longbottom that *Expelliarmus* doesn't require too much flourish, but it does require a "focus on a fixed point." Whereas the Stunning Spell, *Stupefy*, requires more of a fast-pitch overhand flick of the wrist. Harry's best advice for improving wand movements: "Working hard is important, but there's something that matters even more: believing in yourself."

The threatening design of Lord Voldemort's wand influenced actor Ralph Fiennes's technique. "He never holds the wand like everyone else does," observes prop maker Pierre Bohanna. "It's always at the tips of his fingers. It's a very sensitive instrument, as far as he's concerned, so he's always holding it out, and it's always above his head."

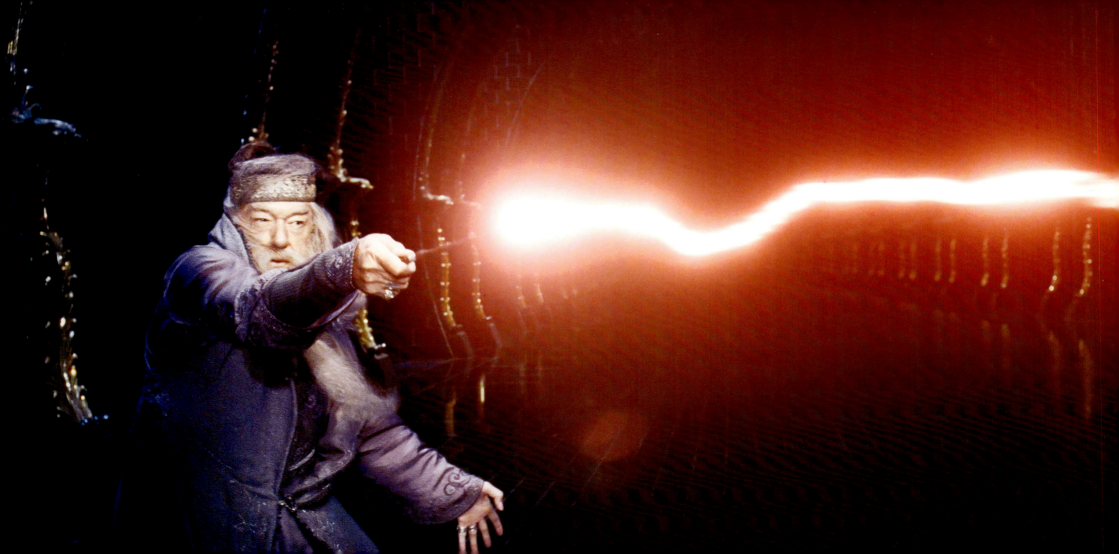

WAND BATTLES

"My wand and Potter's share the same core. They are, in some ways, twins. We can wound but not fatally harm one another. If I am to kill him, I must do it with another's wand."

—Voldemort, *Harry Potter and the Deathly Hallows – Part 1*

When wizards and witches battle, it is a confrontation like no other. The events are showdowns of experience, knowledge, character—and extreme magic. Even the most powerful wizards are put to the test, as when we see Harry Potter and Lord Voldemort duel in the Little Hangleton graveyard in *Harry Potter and the Goblet of Fire* or Albus Dumbledore and Gellert Grindelwald confronting each other at the Ceremony of the Qilin in *Fantastic Beasts: The Secrets of Dumbledore*.

The art and intensity of the wand battles evolved throughout the Harry Potter films, but *Harry Potter and the Order of the Phoenix* was the first film in which the battles rose to an art form of their own. Director David Yates tasked choreographer Paul Harris with creating a set of rules of engagement for the wizards—a specific technique and mode of fighting with wands that hadn't yet been established in previous films.

"David didn't really want it to be a fight, as such," Harris recalls. "He wanted it to have the grace and movement quality that perhaps I could bring to it as a choreographer." But it was more than that. "Given that many of the spells had already been executed without action," Harris says, "I had to devise a set of movements from which the spells could be delivered. A generic family of positions, of movement-based positions from which the spells could be fired." Harris was inspired by the five basic ballet position for five basic wand positions.

Yates's thought was that the battles were getting to a stage where adult wizards were firing wand shots without saying anything. "Therefore, there has to be a language behind it, there has to be a grammar," Harris explains. Yates also points out that a wizard can't just buy a better wand to become a better wizard. "What we thought was that there was something in the inner power of the wizard that could be brought out through their wand technique," says Harris. "There's the body behind it—the being, the power of the wizard—that drives every action."

As the characters learned to master proper wand movements, so did the actors who played them, learning specific actions for specific spells. "What I love most about it is that it doesn't look like anything else," says Emma Watson, who plays Hermione Granger, about the wand choreography of their first real wand fight in *Order of the Phoenix*. "It's about being with your mind, with your body. It doesn't just come from the wand, it comes from who you are." She likens it to its own art form, one that makes you "aware and impressed by what wizards are capable of doing. It's really cool." Evanna Lynch, who plays Luna Lovegood, admits she found it strange to act in battle scenes, "because she's so sort of Zen." But working with Yates, she came into her fighting zone: It's when she is worrying not for her own death but the deaths of her friends. This proves most true in her formidable fight against the Death Eaters in the Hall of Prophecy in *Harry Potter and the Order of the Phoenix*.

The Fantastic Beast films worked hard to raise the very high bar Harris had set for wand battles. In *Fantastic Beasts and Where to Find Them*, Newt Scamander and Tina Goldstein combat both an Obscurial (a dark parasitic magical force) and the disguised Dark wizard Gellert Grindelwald in the subways of New York City. In *Fantastic Beasts: The Secrets of Dumbledore*, there is a spectacular confrontation between the young Albus Dumbledore and his newly discovered nephew Credence, née Aurelius. "We gave Dumbledore and Credence different wand styles and different levels of attack," says supervising stunt coordinator Rowley Irlam. "Of course, actions and the reactions are different depending on the character and their motives: Dumbledore is more controlled, Credence is immature and petulant."

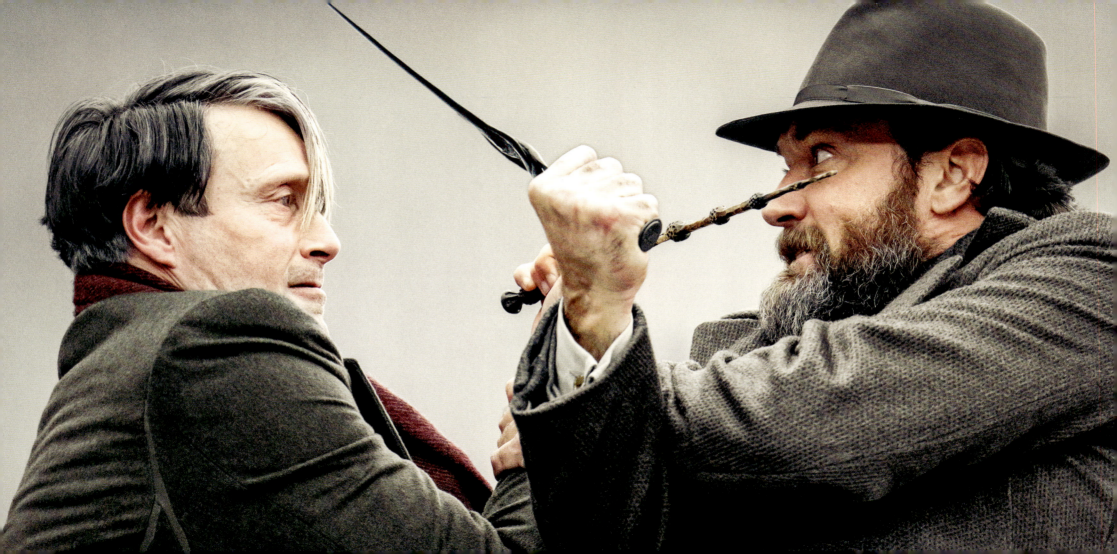

Later, at the Eyrie in Bhutan, Grindelwald's spell to kill Credence is blocked when Albus and his brother, Aberforth, cast protective spells to counter it. Each wand duel is physically choreographed for the actors, but, as Irlam explains, this is only a blueprint allowing for alterations during rehearsals. "Then the actors start pooling their talents," he says. "They're exceptional actors who take our choreography and work with it to make it their own. It's quite rewarding to shape a fight and then have the actors help to polish it and move it forward toward the end product."

Irlam worked with actor Mads Mikkelsen to give Grindelwald an aggressive style, but Eddie Redmayne (Newt) was in awe of Mikkelsen's balletic quality while dueling. "It was compelling and jarring and unique," says Redmayne, who was unaware that Mikkelsen had been a professional dancer. "Seeing his physicality, particularly in the duel with Jude Law, was overwhelming for all of us."

Says Irlam, "It's just trying to find the emotive content and incorporate it within the action, so it isn't just a hacking and slashing sword affair. There's actually some intelligence behind what they're doing."

The
WANDS

HARRY POTTER

Harry Potter, famous as "the boy who lived," acquires his first wand at the age of eleven during his first trip to Diagon Alley to buy school supplies before attending Hogwarts School of Witchcraft and Wizardry.

The wand that chooses Harry in Ollivander's shop is said to be of holly wood with a phoenix feather core. The wand prop seen on film is smooth and unassuming in its design. J. K. Rowling's initial concept for the wizards' wands was that they were "just like an old stick," says draughtsman Hattie Storey, so in the first two films, the wands are mostly simple, straight, and unembellished.

For *Harry Potter and the Prisoner of Azkaban*, director Alfonso Cuarón wanted to reassess the look of the wands, making each one more personal to its wizard, and offered the actors an opportunity to upgrade their wands. Actor Daniel Radcliffe chose a new wand prop with a handle retaining its outer bark, suggesting that it had been whittled from a single root or branch. It was crafted from Indian rosewood, which has a deep red color. The "bark" seen on Harry's wand was sculpted, but the carving was done on real wood. The top of the wand was cast from a tree burr. "This organic design makes it seem more mysterious and magical," says Storey.

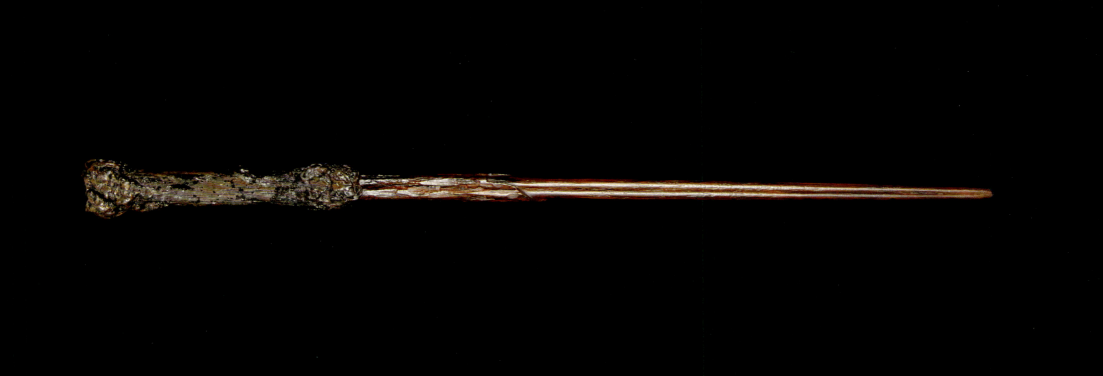

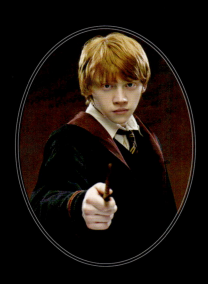

RON WEASLEY

Harry Potter's best mate and fellow Gryffindor Ron Weasley breaks his wand in *Harry Potter and the Chamber of Secrets*. The simple baton-style wand snaps in a confrontation with the Whomping Willow on the Hogwarts grounds.

Although Ron attempts to repair his wand with Spellotape, its reliability thereafter is questionable. When Draco Malfoy calls Hermione Granger a Mudblood, Ron comes to her defense by casting an "Eat Slugs!" spell on Malfoy. The broken wand backfires, however, leaving Ron belching up the slimy creatures himself. Actor Rupert Grint says spitting up the slugs was actually his favorite scene to shoot in the film: "The slugs tasted quite nice! Chocolate, peppermint, lemon, orange . . . there were all these different flavors."

Ron remedies his wand problem by *Harry Potter and the Prisoner of Azkaban*, when his parents buy him a new one. Ron's second wand bears a resemblance to Harry's with the rustic, woody design of its handle. The carving of the shaft has a sculptural effect.

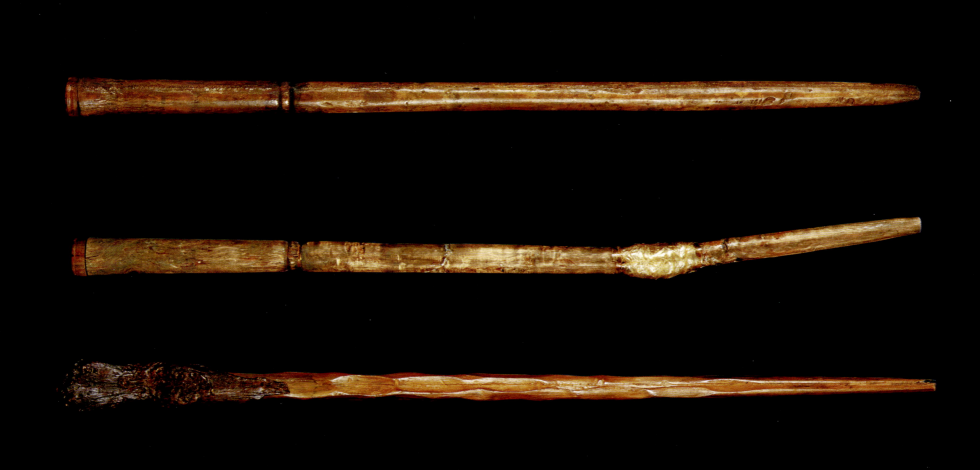

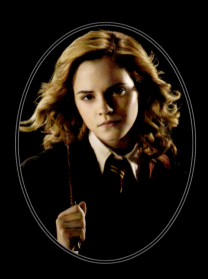

HERMIONE GRANGER

Born to Muggle parents, Hermione Granger is a first-rate witch. In love with learning, she demonstrates a most impressive acumen for spells, and her best friends Harry and Ron wouldn't know what to do without her.

Hermione's wand is carved with a long, tender vine wrapping around its length, revealing a smooth tip. The wand Emma Watson uses in the Harry Potter films was modeled after a hand-carved hardwood called London plane, which was gently stained to highlight the delicate foliage wrapping.

From her first chant of *Oculus Reparo* in *Harry Potter and the Sorcerer's Stone*, when she fixes Harry's broken glasses on the Hogwarts Express, Hermione comes a long way in developing her personal wand style. In *Harry Potter and the Order of the Phoenix*, Watson worked with a choreographer to prepare for the wand battle. "That's the first time we've ever actually had to do any proper fighting with wands," she says. "It's like everything rolled into one: sword-fighting, karate, dance moves, even a bit of *The Matrix*," she explains of the choreography.

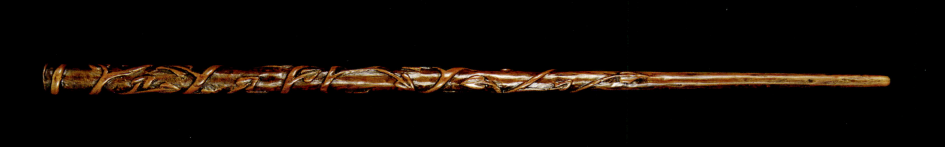

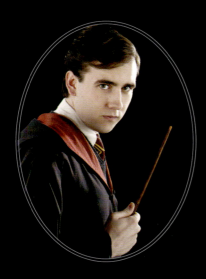

NEVILLE LONGBOTTOM

A son of respected Aurors, Neville Longbottom is sorted into Gryffindor house at Hogwarts. At first seemingly afraid of his own shadow much of the time, by *Harry Potter and the Order of the Phoenix* he is a courageous and formidable member of Dumbledore's Army.

Actor Matthew Lewis never expected his character, Neville, would fight Death Eaters, as he does at the Ministry of Magic. "He's still messing up," Lewis recalls. "But he was brave enough to go out, and he raised his wand, and he was fighting. It was incredible." Before Lewis was cast in the Harry Potter films, he used to pretend he *was* Harry Potter and would play outside with friends wearing bathrobes as wizard robes and using twigs to fire spells at one another.

Neville's first, plain wand, which belonged to his father, is broken in the Battle of the Department of Mysteries in *Order of the Phoenix*. His second wand is marked by its dark wood handle, which spirals into an elegant three-part twist.

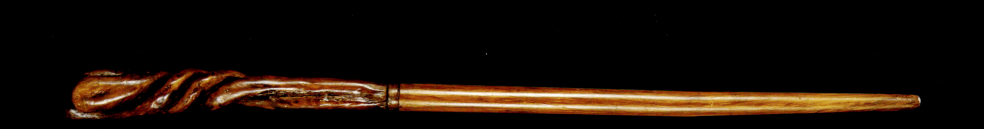

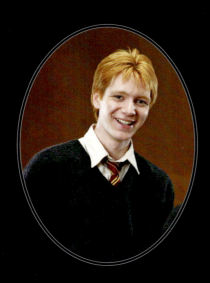

FRED WEASLEY

Fred Weasley, twin brother of George Weasley, has always known that he and his brother are destined for a future "outside the world of academic achievement."

If there are high jinks to be had, Fred and his prankster twin are guaranteed to have them—and profit from them. These entrepreneurial Gryffindors operate Weasleys' Wizard Wheezes, a popular joke shop in Diagon Alley.

Actor James Phelps got a lot of laughs out of the practical joker aspects of the brothers, especially on the Harry Potter film sets. "We can get away with things we wouldn't normally do," he says, "and just say we're in character or something." Early on, James broke one of the wands he used that was made of wood. "Not while shooting any action," says his twin, Oliver Phelps. "It was on a photo shoot!"

Fred's wand sports a long pine-cone handle with a few woody knobs on its shaft.

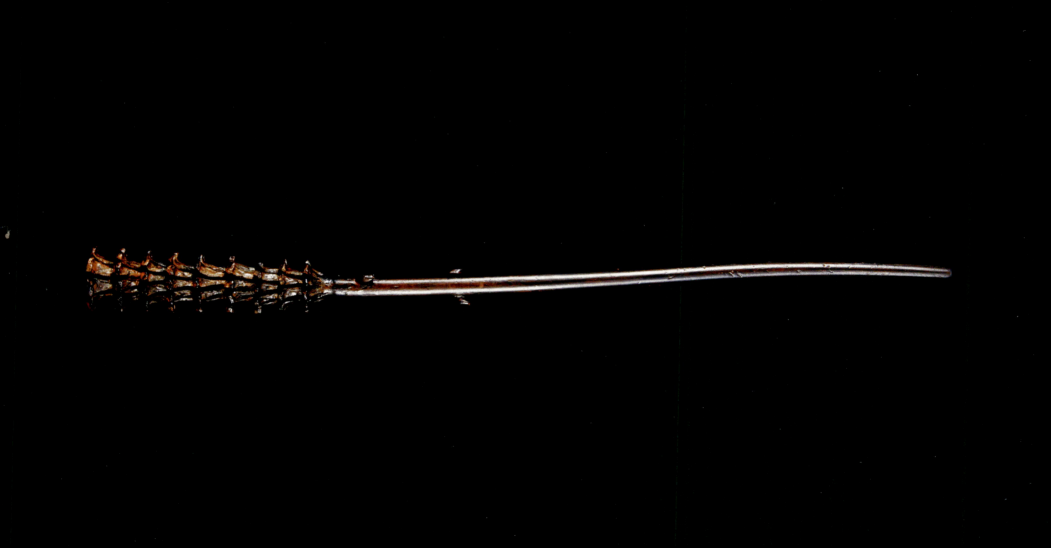

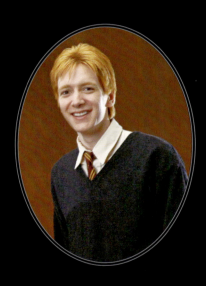

GEORGE WEASLEY

George Weasley, played by Oliver Phelps, is a natural-born trickster alongside his twin brother, Fred. As Hogwarts students, he and Fred have more fun tossing fireworks from atop their brooms than participating in O.W.L. exams.

George's wand can be seen in *Harry Potter and the Prisoner of Azkaban*, as he demonstrates for Harry how to activate the Marauder's Map with a tap of the wand and the phrase "I solemnly swear that I am up to no good."

Though he may physically resemble his brother Fred, George's wand looks nothing at all like his twin's. The former Quidditch Beater commands a wand that is reminiscent of a broom, complete with a saddle. "The newest style broomstick!" insists Oliver Phelps of his character's wand.

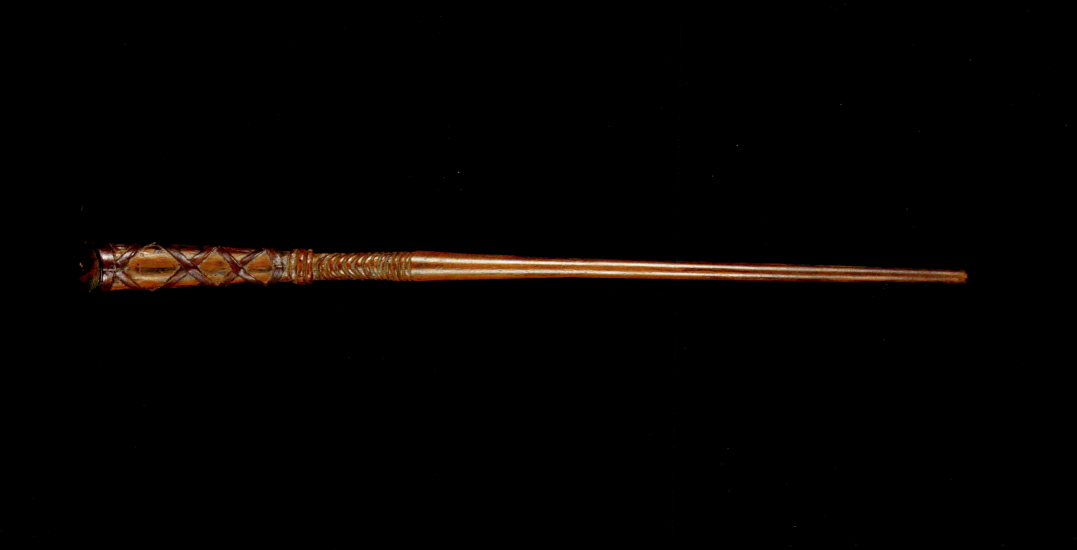

GINNY WEASLEY

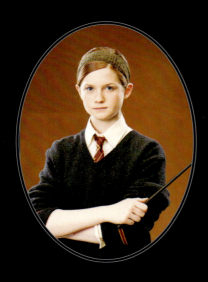

The youngest of the Weasley clan and the only daughter, Ginny Weasley comes into her own during her time at Hogwarts and proves to be a loyal member of Dumbledore's Army. She eventually marries Harry Potter.

An agile and valiant duelist, Ginny fights several battles against Lord Voldemort's Death Eaters, including the Battle of the Department of Mysteries in *Harry Potter and the Order of the Phoenix*, which begins in the Hall of Prophecy. The force of Ginny's *Reducto* curse shatters the vault of its stored prophecies.

Ginny's all-black wand has five twists in the handle, leading into a display of raised crosshatching that separates the handle from the shaft.

Bonnie Wright, who plays Ginny, especially enjoyed observing the unique wand styles used by the actors during filming. "Obviously, everyone holds their pen differently, so it's kind of the same in the way you hold your wand," she says. When new wands were offered to the actors for *Harry Potter and the Prisoner of Azkaban*, Wright felt that, in addition to their look, the wands were chosen for what felt right in their characters' hands.

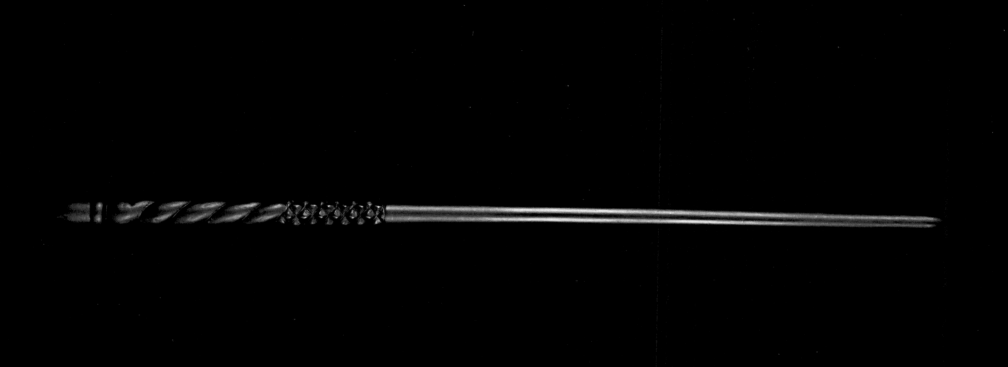

DRACO MALFOY

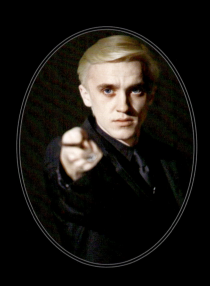

A Slytherin and pure-blood son of a Death Eater, Draco Malfoy uses a hawthorn wand with a core of unicorn hair.

In *Harry Potter and the Goblet of Fire*, Draco's wand-wielding catches the discerning eye of Professor Mad-Eye Moody (really Barty Crouch Jr. using Polyjuice Potion), who doesn't take kindly to back shooters. When Draco points his wand tip at the back of Harry's head, quick-draw Moody blasts Draco with a Transfiguration spell, changing him into a ferret before he can successfully catch Harry off guard.

Actor Tom Felton recalls filming Draco's wand battle against Harry Potter in the bathroom for *Harry Potter and the Half-Blood Prince*: "It was really nice for us, actually, because the entire bathroom was rigged with explosives, so that any time we waved our wands at each other something blew up."

Draco Malfoy's blunt-tipped wand shaft is crafted out of light brown Mexican rosewood attached to a jet-black ebony handle. After Harry takes Draco's wand from him in *Harry Potter and the Deathly Hallows – Part 1*, Draco borrows his mother's wand. Narcissa Malfoy's silver-studded wand is wielded by her son during the skirmish in the Room of Requirement in the final film. Draco's original wand is used by Harry in his final battle against Lord Voldemort.

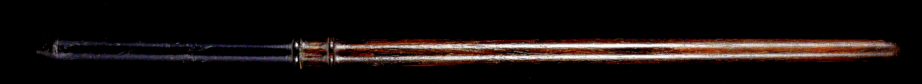

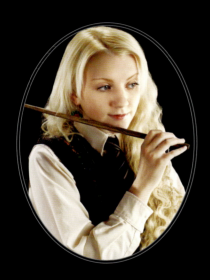

LUNA LOVEGOOD

Luna Lovegood's first wand is baton style, engraved with a vine twisting among acorns. But when this Ravenclaw loses her wand to Death Eaters in *Harry Potter and the Deathly Hallows – Part 2*, it's reasoned that Ollivander, who is imprisoned in Malfoy Manor with her, fashions her a new one. Her second wand is of darker wood, with a handle that resembles a long, flowering tulip.

Actor Evanna Lynch confesses she "was a bit disappointed" when, on the set of *Harry Potter and the Order of the Phoenix*, she recited the incantation *Expecto Patronum* and nothing came out of her wand. Lynch had to picture herself producing the hare Patronus from the tip of her wand, seen by viewers thanks to the visual effects in the final film. "You have to imagine so much!" notes Lynch. "It's actually quite hard."

Luna becomes a key member of Dumbledore's Army and can be seen wielding her first wand in the Battle of the Department of Mysteries, when she sends a masked Death Eater flying by casting *Levicorpus*.

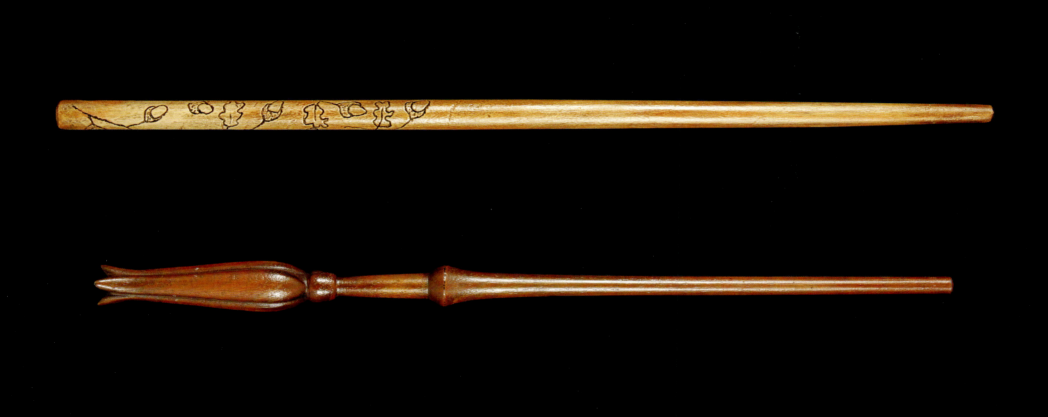

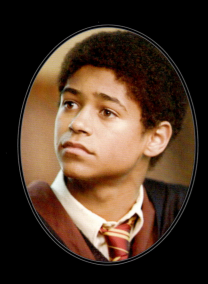

DEAN THOMAS

A half-blood wizard, Dean Thomas is a Chaser for the Gryffindor Quidditch team in his sixth year. A member of Dumbledore's Army, he briefly dates Ginny Weasley and fights in the Battle of Hogwarts in *Harry Potter and the Deathly Hallows – Part 2*. To actor Alfred Enoch, Dean is a pretty ordinary guy who has a good sense of humor and great loyalty to his friends. "I always thought, he'll be all right," Enoch says. "He had it together. I think he's cool and popular, and he went out with Ginny!"

"If I could cast any spell . . ." muses Enoch, "where does it stop? . . . You could do just about anything. It would be great."

Dean's wand is fashioned from smooth, dark brown hardwood rendered in a baton style. At the top of the handle is an organic-looking knob of wood from which spirals of tendrils wrap around the top of the shaft.

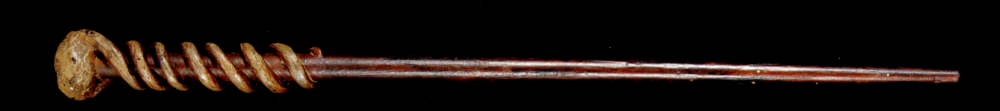

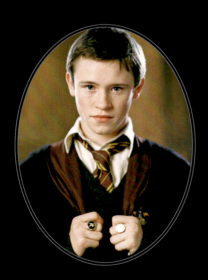

SEAMUS FINNIGAN

Seamus Finnigan is an Irish half-blood wizard and a member of Dumbledore's Army. "Me dad's a Muggle. Mam's a witch," he explains in *Harry Potter and the Sorcerer's Stone*. "Bit of a nasty shock for him when he found out."

Seamus has a "particular proclivity for pyrotechnics," notes Professor McGonagall, who enlists him to blow up the wooden bridge prior to the Battle of Hogwarts. He manages to explode his feather in Professor Flitwick's *Wingardium Leviosa* lesson in *Harry Potter and the Sorcerer's Stone*, and his attempt to brew a draught of Living Death in Professor Slughorn's Potions class in *Harry Potter and the Half-Blood Prince* has a similar end.

Seamus's baton-style wand has a look similar to his best friend Dean Thomas's. It is made from distressed beech, which gives it a grain pattern, with an added mahogany inlay. A black band spirals down from the pommel to around the handle.

"I'm definitely like Seamus in real life, I'm clumsy," says actor Devon Murray. There are wand statistics to confirm it: Murray held the record on set for the most prop wands broken during the course of filming a single scene—ten. He broke so many wands during the ten years of filming Harry Potter that while few actors were allowed to keep their wands after the movies wrapped, Murray was able to keep half of one of his.

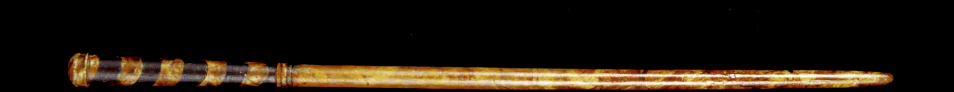

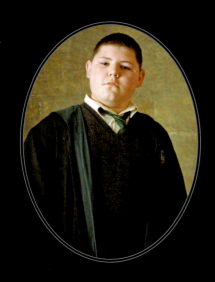

VINCENT CRABBE

The son of a Death Eater, Vincent Crabbe is among the Slytherin set led by Draco Malfoy. As actor Jamie Waylett puts it, "Malfoy leads, and Crabbe and Goyle take orders. I don't think they know how to do anything else."

Crabbe's wand is a light-colored hawthorn that shows the grain of the wood on its blunt-ended shaft. The handle is formed from turned wood with a series of rings at the top, followed by a detail called a "bird's beak" that brackets the major portion of the handle rendered in the shape of what is called a bobbin. A fluted bead and then a cove shape separate the handle from the shaft. The wood here has been lathed with curves to show the darker layers of rings underneath.

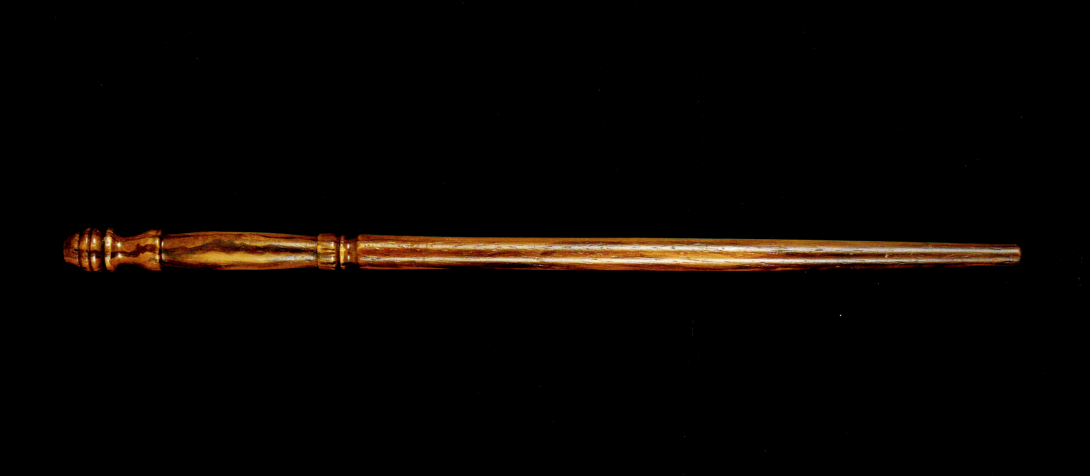

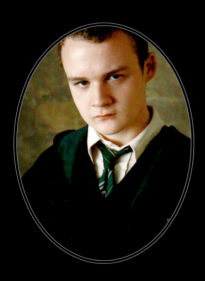

GREGORY GOYLE

Gregory Goyle of Slytherin house chums up with fellow wizards whose fathers are also Death Eaters, namely Vincent Crabbe and Draco Malfoy. Goyle is portrayed by Josh Herdman, who describes his character, as well as Goyle's partner in crime, Crabbe, as "big oafs."

When he fights alongside Draco Malfoy in the Room of Requirement during the Battle of Hogwarts in *Harry Potter and the Deathly Hallows – Part 2*, Goyle casts the intensely hot flames of enchanted Fiendfyre from his wand but cannot control it and sets the room ablaze. He eventually chucks his wand into the fire.

Goyle's wand is two-toned light and dark wood. At the top of the light wood handle is a sphere, and then a bird's beak design at one end of a rough-hewn bobbin shape. Three tight rings separate the handle from the shaft, which is made from a darker, smoother wood ending in a flat tip.

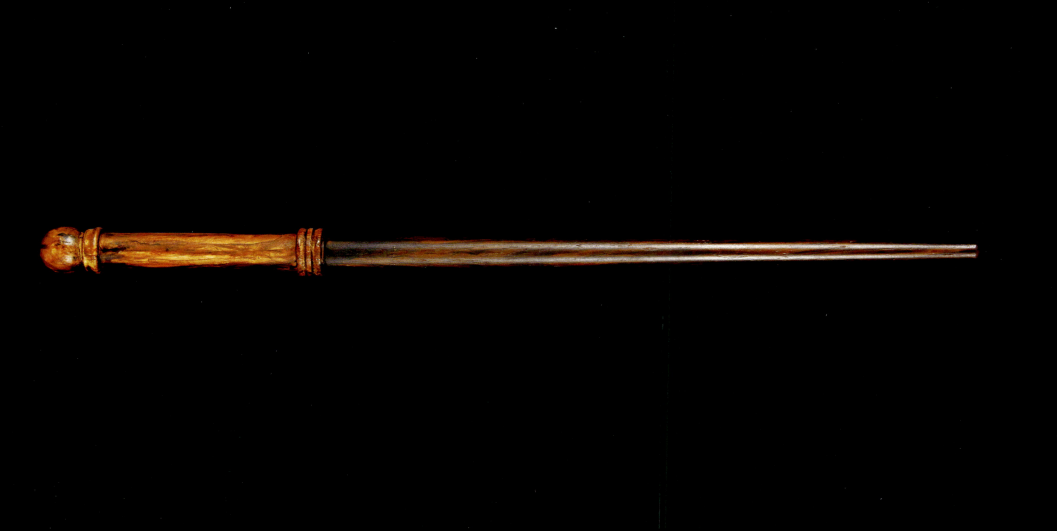

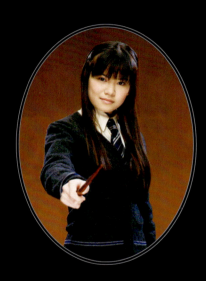

CHO CHANG

A member of Ravenclaw house, Cho Chang dedicates herself to the fight against Lord Voldemort when he has her boyfriend, Triwizard Tournament champion Cedric Diggory, murdered.

As a member of Dumbledore's Army, Cho is "very determined to be taught all this magic," says Katie Leung, who plays Cho. "She wants to avenge Cedric's death." She proves her wand-worthiness in the final battle against the Death Eaters as part of the attack force for Hogwarts in *Harry Potter and the Deathly Hallows – Part 2*. "She is still part of Dumbledore's Army, although she doesn't play such an active role," says Leung. "But she's there for Harry. She's very supportive of what he's doing, and she'll do the best that she can to help him fight Voldemort."

Cho's wand is a rich reddish-brown wood that resembles cinnabar. The wand's design has three distinctive parts: The handle features four twists that flow into a pattern of fossilized leaves on the first half of the shaft. The leaves then segue into an ever-diminishing spiral thread that twirls toward the tip.

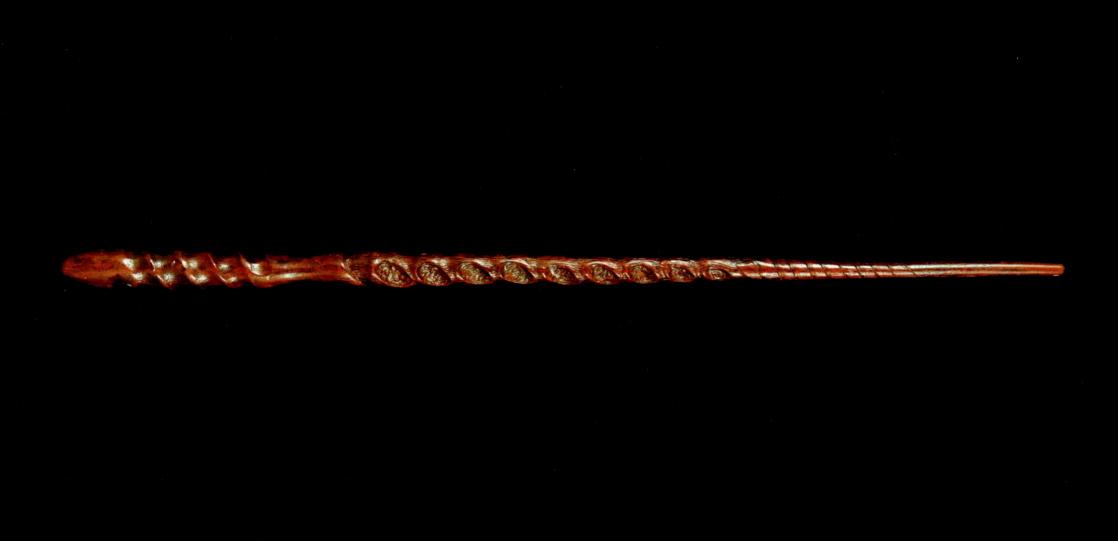

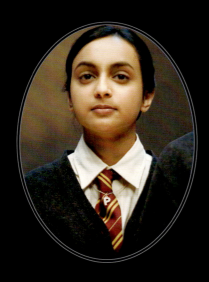

PARVATI PATIL

Sorted into Gryffindor, Hogwarts student Parvati Patil is Harry Potter's date for the Yule Ball in *Harry Potter and the Goblet of Fire* and, along with her twin sister, Padma, an active member of Dumbledore's Army.

It is in Professor Lupin's lesson on Boggarts in *Harry Potter and the Prisoner of Azkaban* where Parvati, played by Sitara Shah in that film, masters the *Riddikulus* spell against the Boggart that represents her worst fear: a hissing cobra. For *Goblet of Fire*, the Patil twins were recast, with Shefali Choudhury portraying Parvati.

Parvati's wand is a warm-toned wood with a raptorlike wrap that resembles the edge of a dragon's wing around the handle.

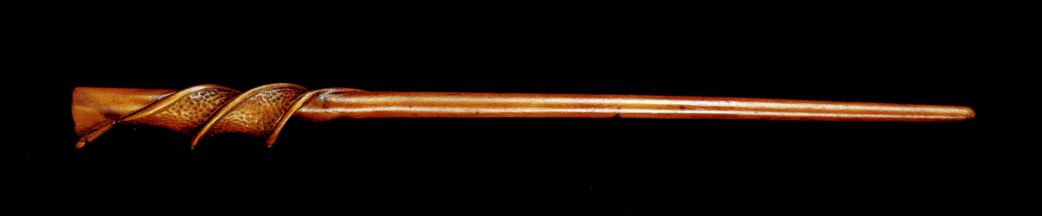

PADMA PATIL

Parvati's twin sister, Padma, is a member of Dumbledore's Army and, in the Harry Potter films, a member of Gryffindor house. Padma, portrayed by Afshan Azad, is Ron Weasley's date for the Yule Ball in *Harry Potter and the Goblet of Fire*, though she abandons Ron after he refuses to ask her to dance.

In *Harry Potter and the Order of the Phoenix*, Padma uses her wand to set a paper swallow flying in Dolores Umbridge's Defense Against the Dark Arts classroom. The bird is incinerated by Umbridge, establishing a punishing tone for the class.

Padma's wand is a simple baton style from tip to top, engraved with runes and alchemical symbols.

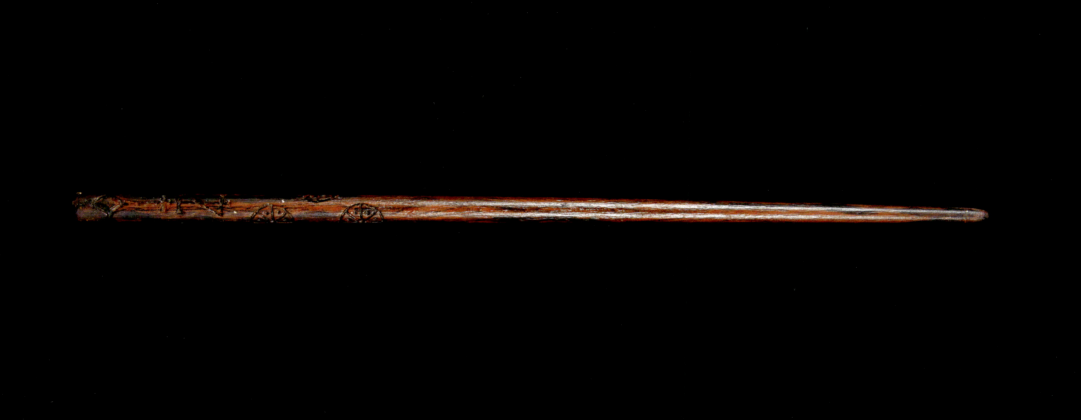

CORMAC McLAGGEN

A member of Gryffindor house and Professor Slughorn's Slug Club, Cormac McLaggen, portrayed by Freddie Stroma, tries out for Keeper of the Gryffindor Quidditch team in *Harry Potter and the Half-Blood Prince*, but loses out to Ron after being hit by Hermione's Confundus Charm. "Cormac is a bully," says Stroma. "He's an arrogant show-off. He's a good Quidditch player, but he knows it. He gives Ron a hard time, and he's constantly going after Hermione."

Later, Cormac is Hermione's date to the Slug Club Christmas party, but she isn't exactly fond of him. "I don't think she has any interest in Cormac whatsoever, but he would like to think so," Stroma states. "Hermione essentially just uses Cormac," explains Emma Watson.

Cormac's wand features a mahogany-colored spiral of rings along its handle. The top is carved throughout to draw attention to its woody grain.

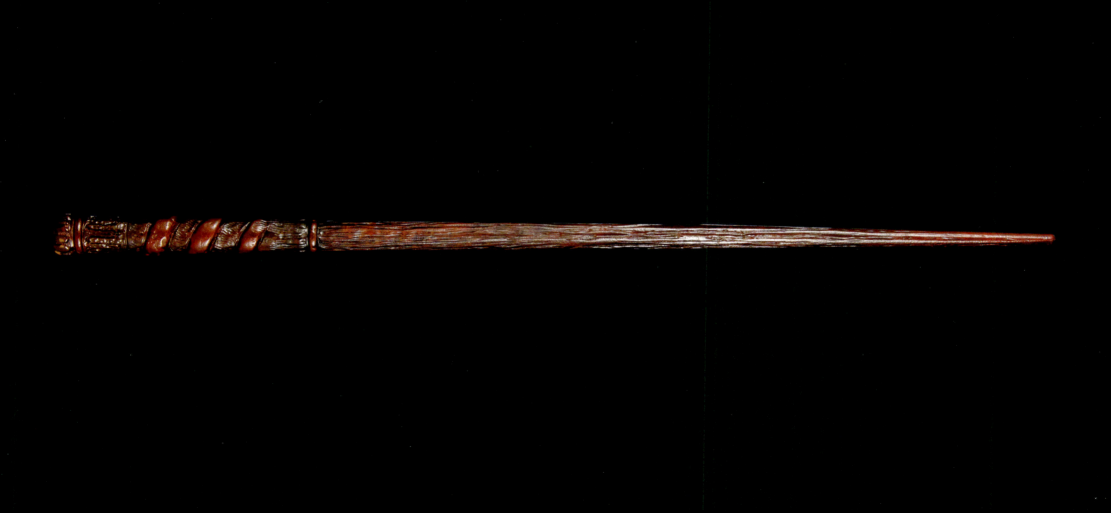

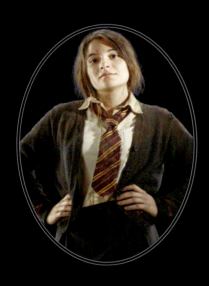

KATIE BELL

Katie Bell is a Chaser on the Gryffindor Quidditch team and a member of Dumbledore's Army. Katie is played by Georgina Leonidas. In *Harry Potter and the Half-Blood Prince*, Katie is cursed by an opal necklace she finds at the Three Broomsticks inn, planted by Draco Malfoy and intended for Professor Dumbledore.

Katie's mahogany-colored wand is quite short and features a subtle design resembling a branch with nodules that have been slowly rubbed smooth.

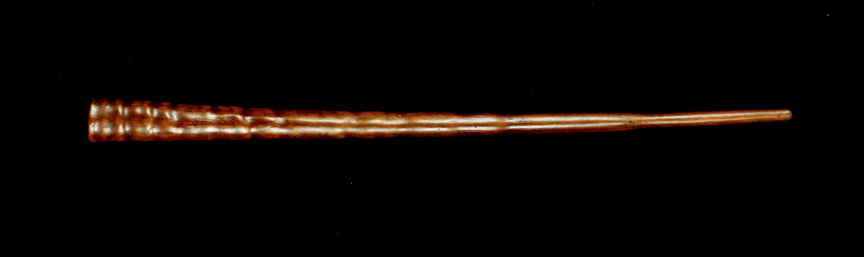

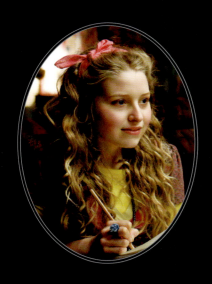

LAVENDER BROWN

Lavender Brown is a member of Gryffindor house and Dumbledore's Army. In *Harry Potter and the Half-Blood Prince*, she falls headfirst into a relationship with Ron Weasley, referring to him as "Won-Won."

Lavender fights bravely in the Battle of Hogwarts in *Harry Potter and the Deathly Hallows – Part 2* but is killed by the werewolf Fenrir Greyback. When Harry, Ron, and Hermione come upon Greyback savaging the lifeless Lavender Brown, Hermione sends the werewolf flying with a flash of her wand.

"She is very bubbly, she likes pink," notes actress Jessie Cave of her character. "I'd like to think she'd have a poodle or something." Lavender's wand is much more subtle and unassuming than you'd expect given her personality. The baton-style wand features a curved black line at the top of its handle and a ring bordered on either side by cavettos—a diminutive form of wood-turned cove—that separate the brown handle from the wand's mahogany-colored tip.

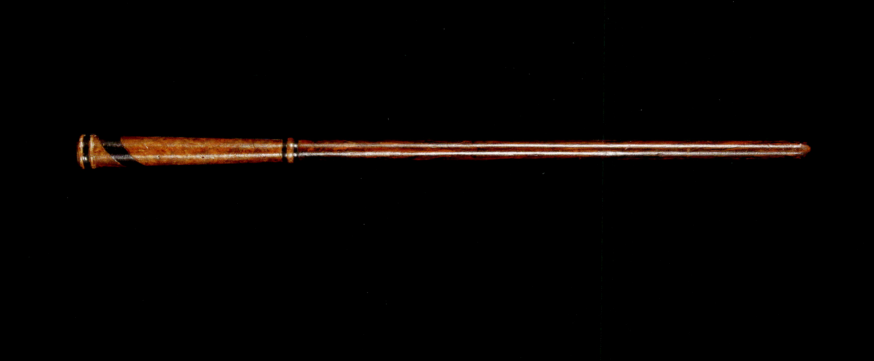

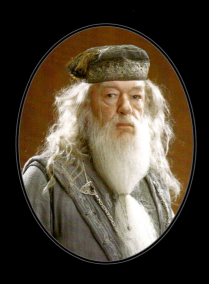

PROFESSOR DUMBLEDORE

One of the most formidable wizards of his time, Albus Dumbledore is best known as Headmaster of Hogwarts School for Witchcraft and Wizardry, founder of the Order of the Phoenix, and wielder of the Elder Wand. But before that, he was the Defense Against the Dark Arts professor at Hogwarts and cast spells with the wand that had chosen him as a child.

The ebony wand Dumbledore uses originally has a natural organic shape, with a twisted stem that concept designer Molly Sole says was a nod to the wizard's "maverick, self-confident nature." The handle is divided from the shaft by a silver collar etched with several runes to invoke wisdom, justice, and strength, and capped with a similar silver piece.

"What was important to me about Dumbledore's wand was that it hinted at where we all know he goes," says actor Jude Law, who portrays the young Dumbledore in the Fantastic Beasts films. Law appreciated touches that went into it that were reminiscent of the Elder Wand, but also liked that its original design reflected Dumbledore's character. "It gave him a certain amount of a young man's dash and flare," Law says.

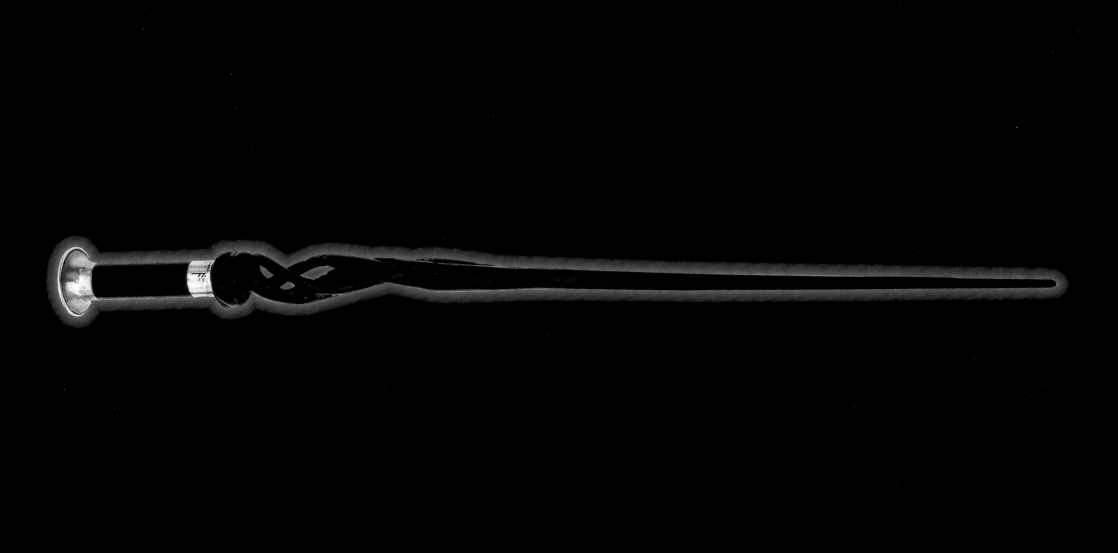

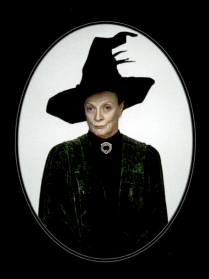

PROFESSOR McGONAGALL

A Transfiguration professor and the Head of Gryffindor house, Minerva McGonagall is a known Animagus, a person who can turn into an animal at will. She's first seen transforming from her tabby cat form into her human form in *Harry Potter and the Sorcerer's Stone*.

"The magic never goes," says Dame Maggie Smith, who plays McGonagall. "I remember walking into the Great Hall for the first time and not believing it, it was so amazing," she says. "It still has that effect on me." In preparation for her wand battle against Severus Snape in *Harry Potter and the Deathly Hallows – Part 2*, Smith and Snape actor Alan Rickman had several rehearsals. "We used our wands almost like foils," she notes, referencing the sensitive weapons used in the sport of fencing. "But, until I see the film, I don't know what magic will come out of the ends of them."

Professor McGonagall's sleek, black-tipped wand exemplifies her no-nonsense sensibility. The handle displays a variety of rings, a long spindle shape, and a sphere featuring a line cut in the middle, called a quirk. The wand's Victorian-style curves are tipped with an amber stone.

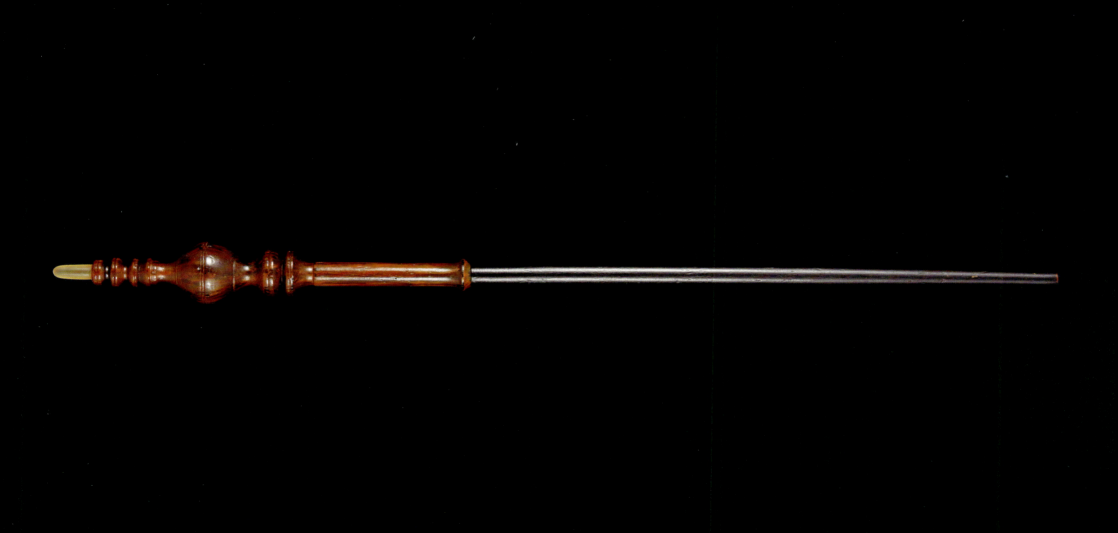

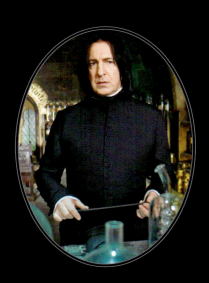

PROFESSOR SNAPE

The Head of Slytherin house and a Potions master, Professor Severus Snape is the "Half-Blood Prince" who developed a penchant for the Dark Arts as a young wizard.

With the use of his wand, young Snape devised his own spells, including the *Sectumsempra* curse, which Harry Potter uses in the sixth film to release a flash of white light from the tip of his wand and slice the flesh of Draco Malfoy. As skillful as Snape is in the Dark Arts, he is equally so in defending against them. His chant of *Vipera Evanesca* eradicates the serpent Draco Malfoy conjures in a duel against Harry Potter in *Harry Potter and the Chamber of Secrets*.

Alan Rickman, who portrays Snape, once explained what it felt like dueling against Professor McGonagall in *Harry Potter and the Deathly Hallows – Part 2*: "Holding a wand isn't the most threatening thing you can do, and pointing it at Dame Maggie Smith, who you've grown up worshiping from the cheap seats at the National Theatre . . . and she's pointing it at you. And she can arch an eyebrow like nobody, so thank God for the sheets of flame."

Snape's wand is spare, black, and confined, reflecting the way the character prefers to carry himself. An intricately carved design marks the handle of his wand, complementing the mysterious complexity of its master.

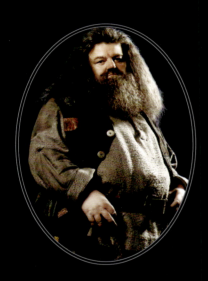

RUBEUS HAGRID

The Keeper of Keys and Grounds of Hogwarts is a job for none other than Rubeus Hagrid, an eight-foot-six, half-giant wizard whose ability to handle even the fiercest of creatures lands him in the position of Care of Magical Creatures professor in Harry Potter's third year.

Hagrid, portrayed by Robbie Coltrane, was expelled from Hogwarts as a student and is not supposed to use his wand. However, he does carry a pink umbrella that has been seen to do magic, such as conjuring a fire, implying that shards of his original wand are cleverly concealed inside. Not the best at following rules, Hagrid attempts to teach Harry's greedy Muggle cousin, Dudley, a lesson by causing him to sprout the tail of a pig in *Harry Potter and the Sorcerer's Stone*.

Hagrid's costumes needed to be created in two different sizes, one for close-ups and one for long shots of his full-height double, and a London umbrella maker did the same for Hagrid's umbrella/wand. Because Hagrid is not actually allowed to use his wand, we do not see him raise it in memorial to Dumbledore in *Harry Potter and the Half-Blood Prince*.

PROFESSOR SPROUT

Herbology professor and Head of Hufflepuff house Pomona Sprout wields a wand that might easily be mistaken for a grainy stick with numerous divots from a tree branch found on the grounds of Hogwarts, or perhaps in one of the greenhouses. There is a bit of carving on it, however, as a bead separates the handle from the shaft, and the wand overall is rendered in a straight baton style.

Sprout, portrayed by Miriam Margolyes, puts her magical plant skills to work against Dark magic by cultivating Mandrakes for their ability to counter the Petrification of students and others, caused by a Basilisk set loose by the Heir of Slytherin in *Harry Potter and the Chamber of Secrets*. When she does take up her wand, it is in devotion to her beloved institution, as she does during the Battle of Hogwarts in *Harry Potter and the Deathly Hallows – Part 2*.

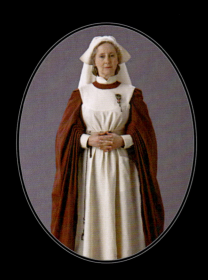

MADAM POMFREY

Hogwarts hospital matron Madam Poppy Pomfrey carries a wand as practical as she is, fashioned of hardwood with an unknown core. Its dark, knobbed handle resembles that of a simple bedpost.

Madam Pomfrey's expertise is magical medicine, but not everything is possible with a mere incantation, and so, in *Harry Potter and the Deathly Hallows – Part 2*, she works her wand to hurt as well as heal, as she successfully fights off at least one Death Eater during the Battle of Hogwarts. Actress Gemma Jones calls it Pomfrey's "last hurrah." "I spend a lot of [time] tending to the wounded in the Great Hall," she explains, but Pomfrey also takes part in the battle, which Jones found very enjoyable. "I'm fighting the Death Eaters with my wand, so I had a good time," she says. "At my age and station, it was a very good workout."

The wand battles were "a bit tame" at first, Jones confesses. "But," she says, "when everything's put on in special effects, with sparks and flashes coming out of our wands, you realize how powerful you are."

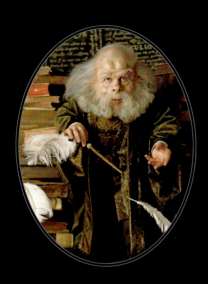

PROFESSOR FLITWICK

In *Harry Potter and the Sorcerer's Stone*, the aged, bearded, and bald Charms professor Filius Flitwick wields a distinctive dark wood wand. The handle is carved in a bobbin shape and finished with a white carved sphere before a spiral-wrapped shaft. "I have two different wands in *Harry Potter*," says actor Warwick Davis. "In the first two films, when I played the older-looking Flitwick, I had quite an intricate wand that consisted of many different materials. It was wood and it had a kind of pearlescent handle and then a kind of brass tip . . . [that] connected with your hand."

When Davis appeared as the choirmaster in *Harry Potter and the Prisoner of Azkaban*, he uses a different wand to go with Flitwick's radically different appearance. *Harry Potter and the Goblet of Fire* director Mike Newell liked the younger, more formal look so much, he asked if it could become Flitwick's. Of course, Flitwick's wand was updated along with his costume. The new wand is fashioned from one single piece of wood from its darkened tip to its lighter end, which separates into four rounded parts that resemble the feathery shafts of an arrow.

When Flitwick conducts the orchestra at the Yule Ball in *Goblet of Fire*, he uses another wand, crafted from resin, that bears an uncanny resemblance to a baton-shaped icicle.

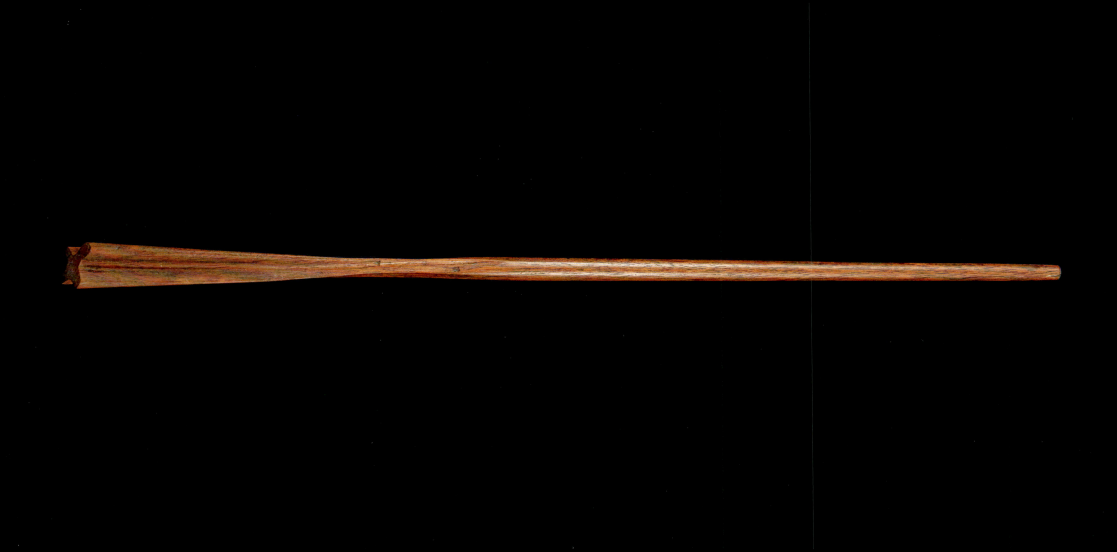

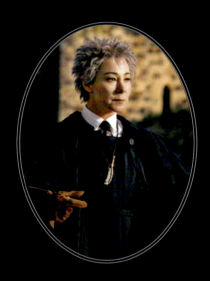

MADAM HOOCH

Flight instructor and Quidditch referee Madam Rolanda Hooch is well known among Hogwarts first-year students as the master of proper form and technique for mounting and flying brooms. "Brush backward, of course," says actress Zoë Wanamaker, who plays Hooch, "otherwise you'll *go* backward."

Hooch is quick with her wand to try to help Neville Longbottom when he can't control his broom during their first flying lesson in *Harry Potter and the Sorcerer's Stone*, but unfortunately, he falls to the ground before she can speak an incantation.

Fitting for a referee, Madam Hooch's wand has something of a neutral baton design, fashioned in a medium-dark wood that shows evidence of the grain. Two tight rings separate the shaft from the handle, which ends in a subtly carved knob.

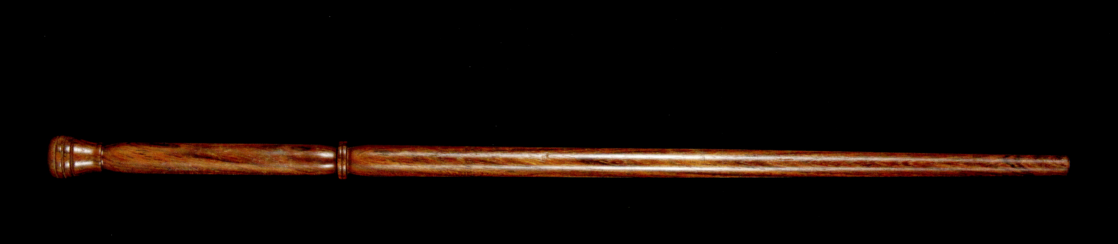

PROFESSOR LOCKHART

Gilderoy Lockhart is a dandy of a professor but a disaster of a Defense Against the Dark Arts instructor. "He's the kind of guy that, if you've been to the moon, he's been there twice," says actor Sir Kenneth Branagh of his braggart character. Producer David Heyman says Branagh "embraced the narcissism full-heartedly."

The wand used by Branagh in *Harry Potter and the Chamber of Secrets* is a good fit for Lockhart's showy personality. Though most of the wands in the first two Harry Potter films are very simple, Professor Lockhart's is adorned with an elegant lily shape at the top of its handle. In a reverse of many of the wands, the shaft is constructed from a light wood and the handle is brown. At his Dueling Club demonstration for Hogwarts, Lockhart hangs his wand from loops on his trousers, similar to the way a fencing sword is holstered.

When Lockhart tries to stop a cage of Cornish pixies from wreaking havoc in his classroom by chanting *Peskipiksi Pesternomi*, he only succeeds in losing his wand to one of the creatures. His Memory Charm works wonders, however—when he seizes Ron Weasley's broken wand in the Chamber of Secrets, his incantation of *Obliviate* backfires onto him by virtue of the defective wand, wiping out all the professor's memories.

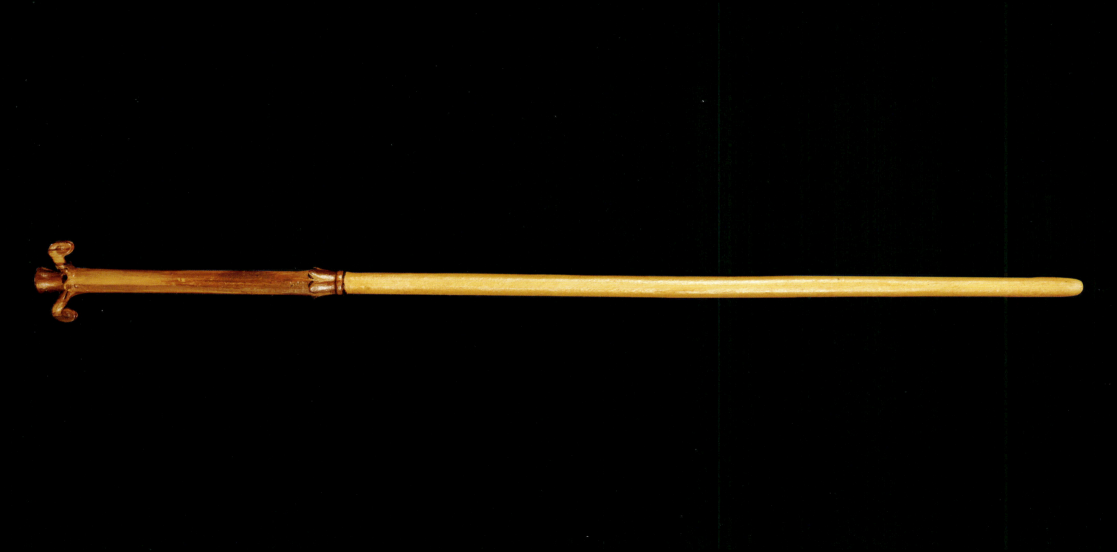

PROFESSOR LUPIN

Harry Potter's third-year Defense Against the Dark Arts professor, Remus Lupin, has a dark side himself, as he struggles with the duality of being a werewolf.

In *Harry Potter and the Prisoner of Azkaban*, Lupin is quick with his wand against a dementor that boards the Hogwarts Express in search of Sirius Black. Later, while teaching Harry's class to defend themselves against Boggarts, he intercepts Harry's dementor Boggart with his own full moon Boggart, which turns into a balloon with the *Riddikulus* spell.

The wand actor David Thewlis uses when on-screen as Lupin is carved out of olive wood, with a balled, moonlike handle that twists into a straight baton point. Prop maker Pierre Bohanna describes the design as "gentle."

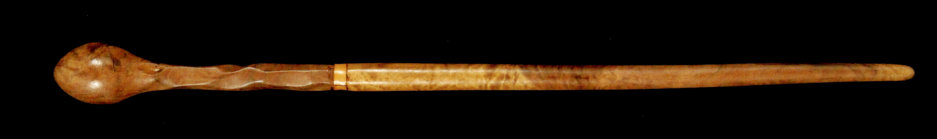

PROFESSOR MOODY

Ex-Auror and Order of the Phoenix member Alastor "Mad-Eye" Moody comes to Hogwarts to teach Defense Against the Dark Arts in *Harry Potter and the Goblet of Fire*, but the professor is eventually revealed to be Barty Crouch Jr. using Polyjuice Potion. Moody is "a gunslinger with a wand," as actor Brendan Gleeson describes his character. After all, he's responsible for sending more than half of the Death Eaters to Azkaban prison.

Moody actually has a total of four wands to use, including a silver one dedicated to the repair of his prosthetic leg. "I asked if it could look like a replica of a spire in Dublin," says Gleeson. "It was used only once, but if I could have one, that would be the one I always cast my eye on, so to speak."

The dark red wood of the wand Moody uses predominantly is most visible at the top of its rounded handle, which resembles the top of his walking stick. The handle also has a natural pock, a socket to match Mad-Eye himself. The shaft of the short wand has a barklike texture and is banded in silver and bronze.

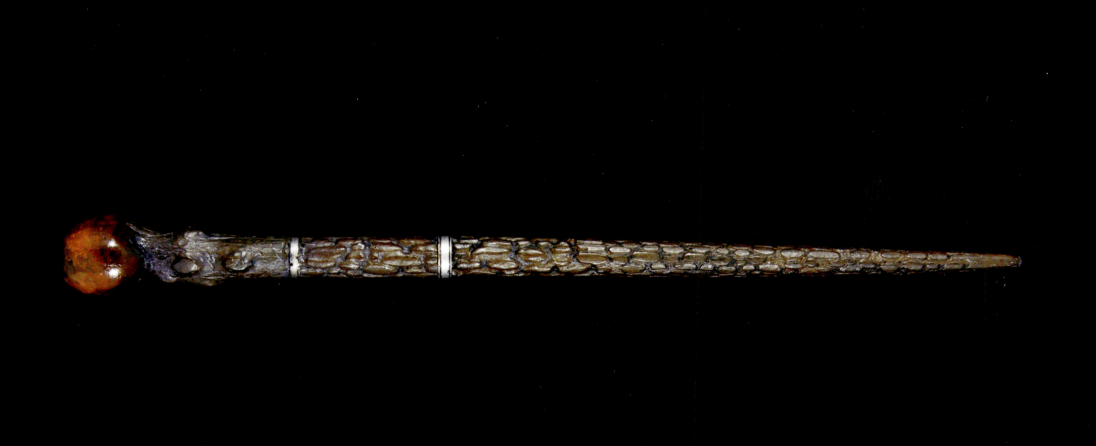

PROFESSOR UMBRIDGE

Never without her signature pink, from her hats to her shoes, Professor Dolores Umbridge is a proud Senior Undersecretary to the Minister for Magic, Hogwarts Defense Against the Dark Arts professor, High Inquisitor, and Headmistress, first seen in *Harry Potter and the Order of the Phoenix*.

She appears soft yet is fierce to the core. Actress Imelda Staunton describes her as someone with "little power . . . but she will hang on to it." Though she scolds her students for their wand use, she has no problem threatening Harry with the Cruciatus Curse in *Order of the Phoenix*.

Fit to her stature, Umbridge's wand is remarkably short. Its dark wood is fashioned into a tight stacking of concentric beads, punctuated with a pink gemstone in the center. The wand was created in purple mahogany wood but cast in resin in a clear color before staining.

PROFESSOR SLUGHORN

Horace Slughorn comes to Hogwarts to fill the post of Potions master in *Harry Potter and the Half-Blood Prince*, during the year Professor Snape finally becomes the Defense Against the Dark Arts professor. Slughorn has a certain penchant for "collecting" students of renown and wants Harry Potter to become his latest acquisition.

The double curve in the length of Professor Slughorn's wand evokes a slug on the move. "Slughorn is a great example of putting characteristics of the characters into the wand. He's a fantastic one, a sort of great balance of ego and daftness in him," says prop maker Pierre Bohanna. The wand was made from a process called lost-wax casting, which dates back thousands of years: When the mold of the wand is made, its metal elements are created in wax. As it is heated, the wax melts away, and then liquid metal is injected into the mold. Slughorn's wand took the longest to make and was one of the heaviest wands created for the films.

"It's a fantastic job," says Slughorn actor Jim Broadbent. "Every detail of it, all the props and the furniture and everything is absolutely perfect."

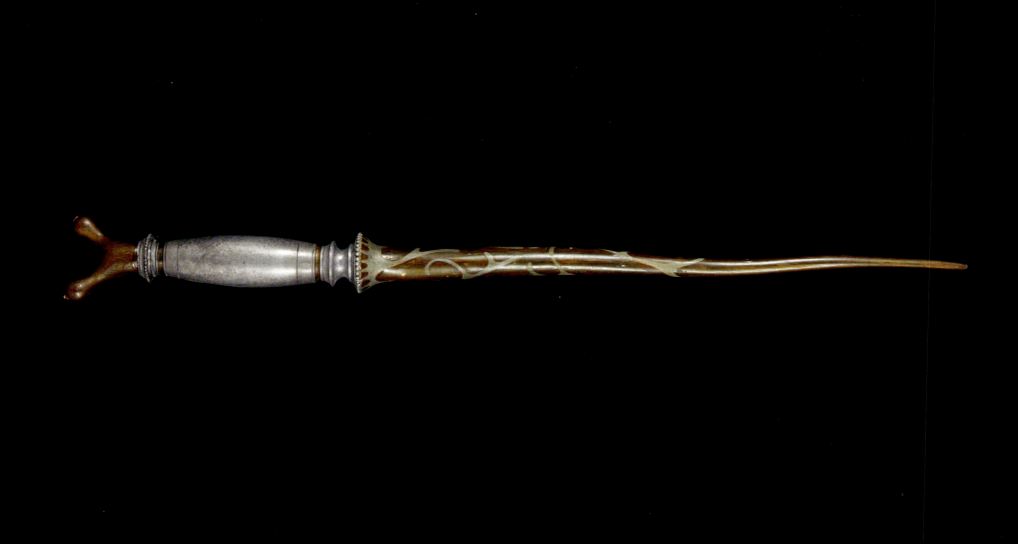

PROFESSOR TRELAWNEY

As Harry learns in *Harry Potter and the Order of the Phoenix*, it was Sybill Trelawney who foretold of the boy with the power to defeat the Dark Lord.

Costume designer Jany Temime worked closely with actress Emma Thompson to perfect the look of Trelawney's attire, made of material decorated with little mirrors. "I've got eyes all over my costume," says Thompson—a fitting design for someone who tries to see into the future.

Trelawney's wand looks like a cross between a hairpin and an eating utensil. A carved spiral emanates from the tip of the shaft into a square handle inscribed with runes and symbols that refer to celestial bodies such as minor planets and asteroids, including Ceres, Hebe, and Melpomene.

When it comes to learning how to use magic, Thompson compares it to learning how to do housework: "The practicality of it is the fact that it's every day, and you just need to learn how to do these things, and it's obvious, and let's get on with it."

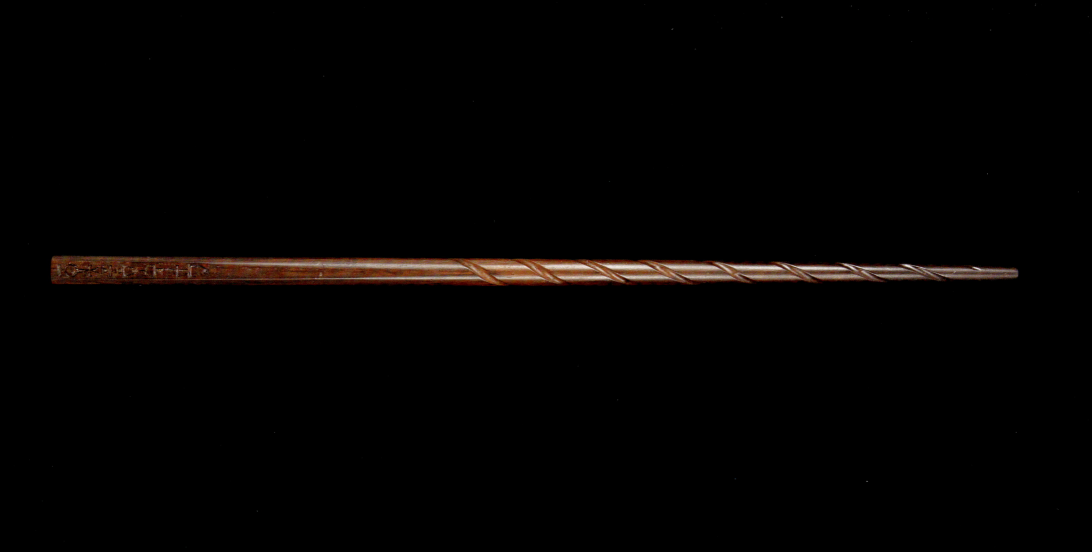

CEDRIC DIGGORY

Cedric Diggory, played by Robert Pattinson, is a Hufflepuff Prefect, a distinguished Seeker, and Quidditch team captain. He becomes one of two Hogwarts champions in the Triwizard Tournament seen in *Harry Potter and the Goblet of Fire*.

Cedric's wand is a black-tipped, baton-style wand. It was fashioned from the same mold as Padma Patil's wand but made lighter in color and then etched with wheellike designs and alchemical symbols on its handle.

Cedric is one of the few two-handed wand wielders seen in the films, a result of Pattinson not feeling as comfortable with wand work as the other actors. "I remember holding a wand and thinking that it felt so dorky to hold it like a magic wand," he explains, so he decided to hold it like a gun. "I think I even have one eye closed [when I use it] . . . like it's got a view-finder on it."

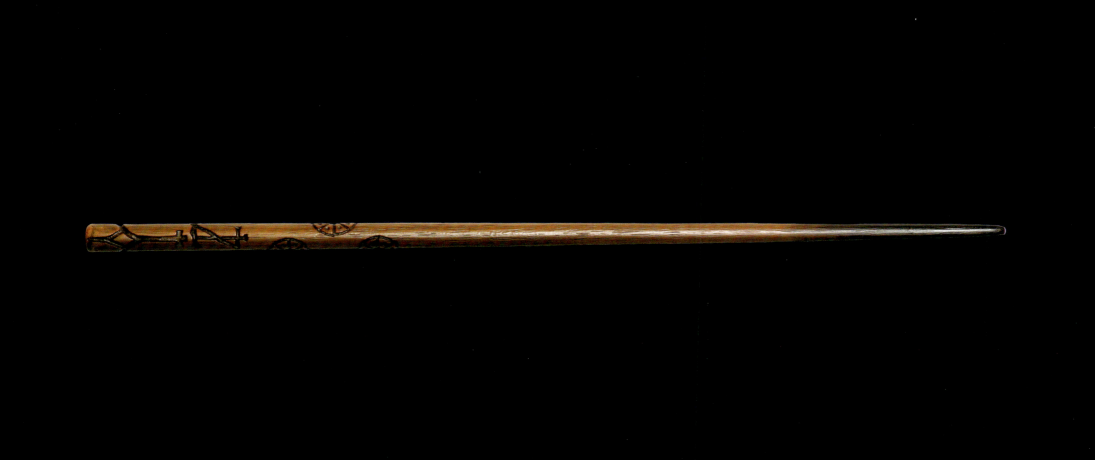

FLEUR DELACOUR

Beauxbatons Academy of Magic student Fleur Delacour is the Triwizard Tournament champion of her school. Actress Clémence Poésy describes Fleur as "what the English think a French girl should be. She's very chic and very Miss Perfect all the time, quite graceful and quite serious."

Beauxbatons wands are as chic as the French school's students. And like the uniforms worn by the girls who wield them, the wands are topped with a tasteful flourish. However, in the Battle of Hogwarts in *Harry Potter and the Deathly Hallows – Part 2*, Fleur fights for more than just school pride. "Fleur's been brave, and now she's battling," says Poésy, who studied wand choreography to ensure she had the correct moves. "She fights. It's a true Weasley she becomes."

Fleur's wand is as elegant and graceful as she is. The handle curves with a flourishing spiral. A luxurious leaf wraps itself along the length of the tapering wand, suggesting the edge of a petticoat or parasol.

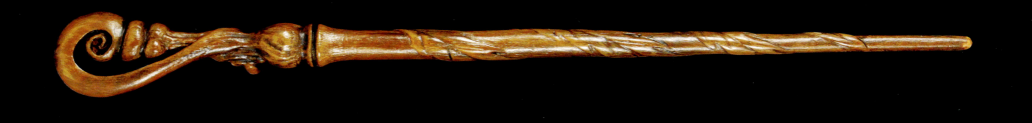

VIKTOR KRUM

Durmstrang Institute student and Bulgarian National Quidditch Team Seeker Viktor Krum is the Triwizard Tournament champion for his wizarding school. Actor Stanislav Ianevski says he wanted Krum to be "a special and very impressive character, since he is more of a physical type with expressions and presence rather than dialogue."

The Durmstrang Institute is known as one of the leading schools for magic in all of Europe, set in the northern realm of the continent. Producer David Heyman describes the fierce, cool attitude of the Durmstrang boys as "quite austere and intimidating." And so are their wands.

In the final task of the Triwizard Tournament, Krum and Cedric Diggory spot the Triwizard Cup at the same time and begin a wand duel. "Then Harry just appears, in the middle of that fight," says Ianevski. "Krum yells pretty loud in Bulgarian, telling Harry to get out of the way." This allowed Ianevski to speak in his native tongue, which he felt fans would enjoy.

Viktor carries a wand whose handle resembles a bird's head, a nod to the eagle symbol of the Durmstrang Institute. It is thick and roughly cut, with a natural curve.

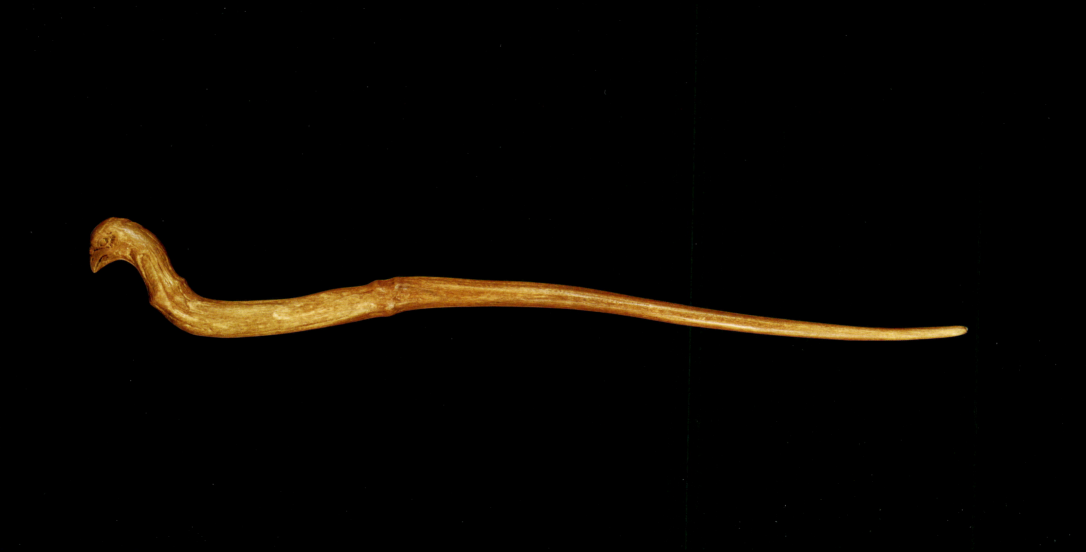

SIRIUS BLACK

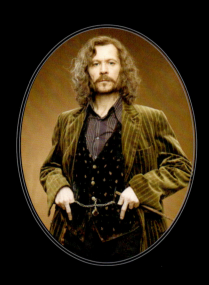

Wrongfully imprisoned in Azkaban for the assumed murder of Peter Pettigrew and the death of twelve Muggles, Sirius Black is the godfather of Harry Potter.

Sirius is a great comfort to Harry when he becomes unsure whether he is becoming more like Voldemort as he grows older. "We've all got both light and dark inside us," Sirius tells him. "What matters is the part we choose to act on." In the Battle of the Department of Mysteries in *Harry Potter and the Order of the Phoenix*, Sirius wields his wand for good in a fatal fight, when Bellatrix Lestrange uses the Killing Curse on him.

Gary Oldman, who plays Sirius, enjoyed working with choreographer Paul Harris on the fight in the Death Chamber. "There are certain ways of using the wand, certain movements, a certain physicality. One spell may be above the head, another spell may be from down below. In action, [the wand is used] aggressively, and quite violently, really." Oldman was instructed by Harris to give his wand moves more of an angular, "street" feeling, which he thought befitted someone who had spent time in Azkaban.

Sirius's wand tapers from a square handle into a length engraved with a twisting trail of circles and dots set within a sinewy spiral along the shaft. The runic symbols along the flattened ends complement the tattoos that ink his body.

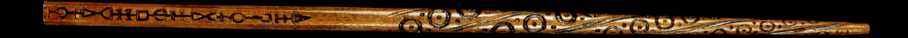

NYMPHADORA TONKS

Nymphadora Tonks is an Auror, a Metamorphmagus, and the wife of Remus Lupin, a known lycanthrope.

Actress Natalia Tena tried to incorporate a dance element into her wand style. However, her character is not known for her physical poise: "So, I do this massive spell, and when I landed, I meant to be like a ballerina—very graceful. And then I trip up. So, Tonks's style is that she is very good, but she just can't help getting it wrong."

As a member of the Order of the Phoenix, Tonks fights bravely against Voldemort's Death Eaters in the Battle of the Department of Mysteries in *Harry Potter and the Order of the Phoenix*, and again in the Battle of Hogwarts in the final film, which, sadly, leads to her death.

Tonks's wand is carved of two different woods, with a banded shaft that opens into a jack-in-the-pulpit flower for its handle. Tena confesses that despite extensive wand training, it wasn't until filming *Harry Potter and the Deathly Hallows – Part 1* that she learned how to truly hold her wand upon discovering "a little nook to work with!"

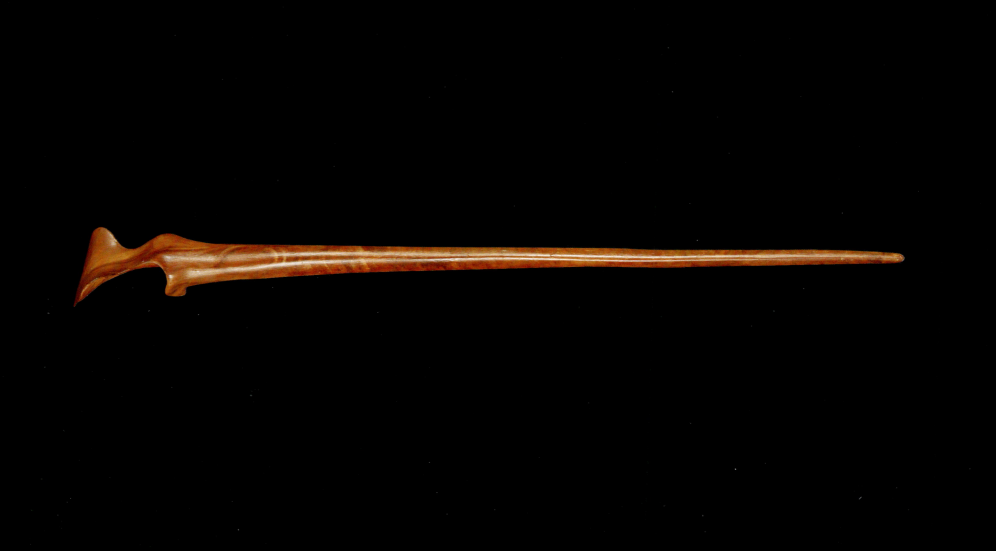

KINGSLEY SHACKLEBOLT

Kingsley Shacklebolt is an esteemed Auror and a member of the Order of the Phoenix. When the Ministry of Magic falls to Death Eaters in *Harry Potter and the Deathly Hallows – Part 1*, Shacklebolt sends his lynx Patronus to the Burrow to alert the guests at Bill and Fleur's wedding.

Actor George Harris describes Shacklebolt as someone who "has a quiet strength and wants to keep a lid on it." Though his character's clothes are flashy, "he wouldn't have any big flashy wand moves," says Harris. "Economy is very, very, important in the Order. His tendency is to be quite quick and very effective." It is fitting that his wand suggests the same quiet strength with its multiple layers of wood and elegant, definitive carvings. Yet when it comes to the Battle of the Department of Mysteries in *Harry Potter and the Order of the Phoenix*, Harris says, "I can't wait to get my wand out."

The Auror's wand is a combination of several woods put together with a very organic structure in their design and a handle that is suggestive of a germinating plant.

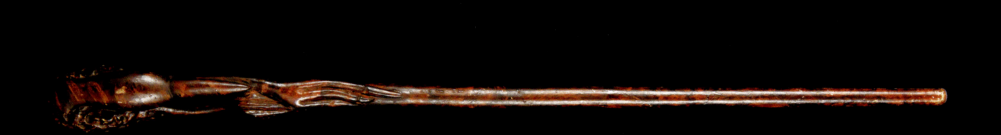

MUNDUNGUS FLETCHER

Mundungus Fletcher, portrayed by actor Andy Linden, is among the Order of the Phoenix members who arrive at number four Privet Drive to escort Harry from the house in *Harry Potter and the Deathly Hallows – Part 1*. Unlike everyone else, Mundungus's participation in the operation isn't exactly voluntary. "Technically, I've been coerced," he explains.

Later in the film, when Kreacher and Dobby bring him into number twelve Grimmauld Place, Mundungus claims to be a "purveyor of rare and wondrous objects." Ron disagrees. "You're a thief, Dung, everyone knows it," he says. When he tries to whip out his wand in the Grimmauld Place kitchen, Mundungus is promptly disarmed by Hermione.

Fitting for a man who will go to great lengths to get his hands on valuable items, Mundungus Fletcher's wand features a golden sphere, reminiscent of a ring gemmed with a large black stone, set between the flaring handle and a stubby, splintered shaft. At the top of the wand is a golden icon resembling a lion.

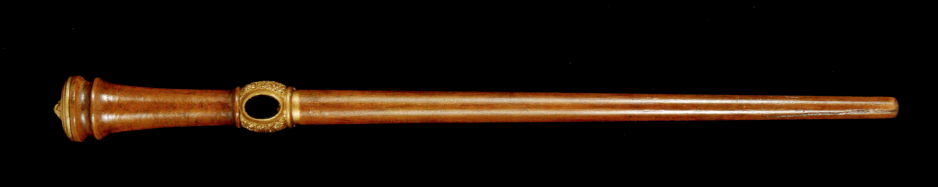

MOLLY WEASLEY

Molly Weasley is the mother of seven children, wife to Arthur Weasley, and proud member of the Order of the Phoenix, with an exceptional talent for knitting.

"It's huge maternal stuff, to protect your children," says actress Julie Walters, "and that's what she's about." Walters found waving a wand around all day could become painful, but says, "I felt like a warrior with it. It was heaven when I first got to use the wand." She knows it was all worth it during her fateful battle with Death Eater Bellatrix Lestrange in *Harry Potter and the Deathly Hallows – Part 2*. "Mrs. Weasley is a little bit rustier and she's not as fit, so her style probably isn't as fluid or dramatic as Bellatrix's style," says Walters. "Of course, Bellatrix is thinking, 'Come on, Granny,' but she has no idea what she's up against when she takes on the fierce, protective love of a mother."

Mrs. Weasley sports a modest wand: simple, practical, and well-darkened with use.

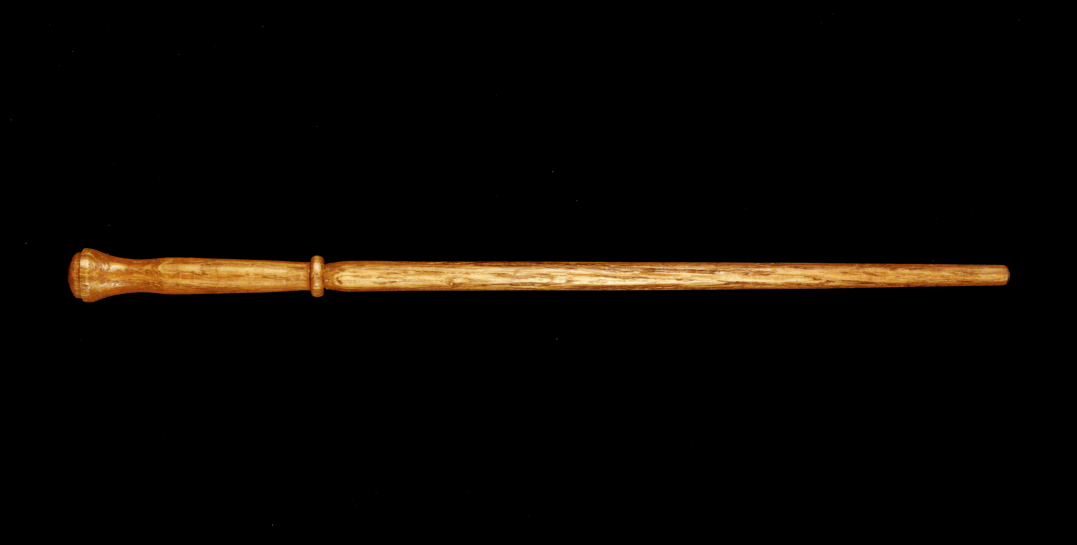

ARTHUR WEASLEY

Arthur Weasley, head of the Weasley clan, works at the Ministry of Magic. He has a particular affinity for Muggles. Even if his appearance seems a little used and worn-out, Arthur's touch with his wand is not, as he proves battling a Death Eater during the Battle of Hogwarts.

The wand for the Head of the Misuse of Muggle Artifacts Office is a practical one, with an elegant turn to it that prop designer Pierre Bohanna describes as "a sugar barley twist." Barley sugar is a traditional English hard candy that is typically fashioned into the shape of a twisted stick. Both the tip of the wand and the end of its twisted handle have a flattened surface.

Actor Mark Williams felt his wand was very elegant. "I was quite fond of it," he recalls, "except that I developed a strange posture with it." The right-handed Williams found that he would consistently use his left hand to pick up the wand. "So, my choreography became a bit twisted," he says. "Well, you can't say I didn't have my own personal style!"

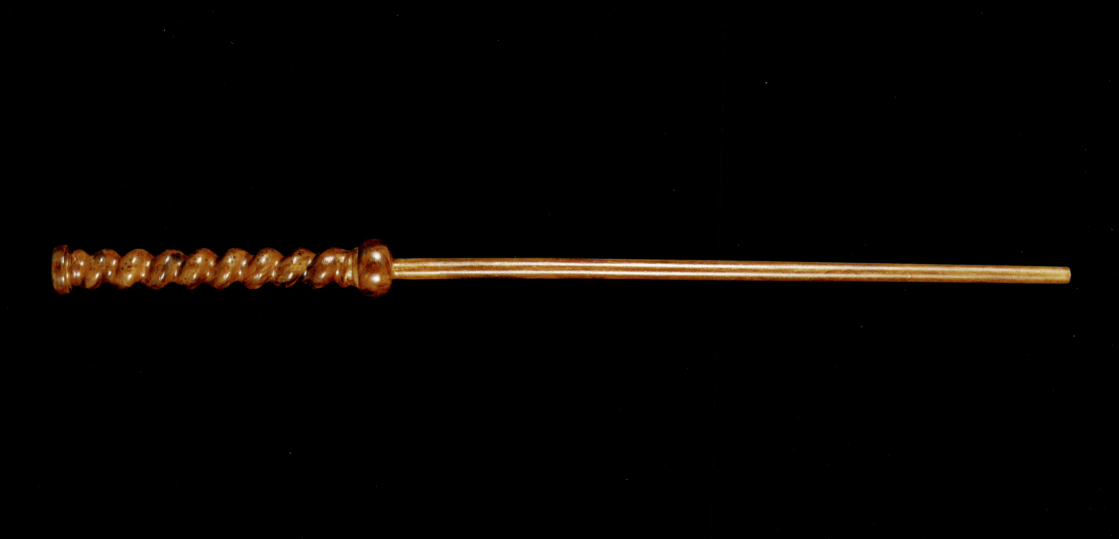

GARRICK OLLIVANDER

A master of wand lore and the proprietor of Ollivanders wand shop in Diagon Alley, Garrick Ollivander, portrayed by John Hurt, is widely considered the most sought-after wandmaker in the entire wizarding world.

Ollivander remembers every wand he has ever sold. He knows better than anyone, as he tells Harry in *Harry Potter and the Sorcerer's Stone*, that "it is the wand that chooses the wizard. . . . It's not always clear why." It's Ollivander who explains the subtle laws of wand ownership to Harry in *Harry Potter and the Deathly Hallows – Part 2*, describing how Draco's wand has responded to being won by Harry at Malfoy Manor. "I sense its allegiance has changed," remarks Ollivander.

Ollivander's wand features a gnarled, organic design, as if it were carved from a tree twisted with age. The wand's handle has a distinctive curve and is etched at its base with a few runic marks among the wizened wrinkles of the wood.

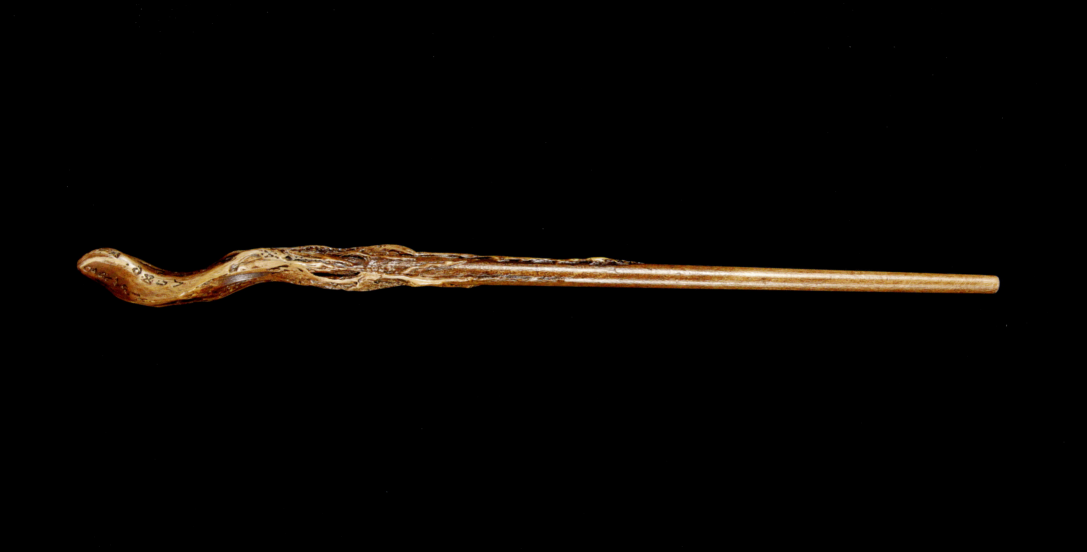

XENOPHILIUS LOVEGOOD

Xenophilius Lovegood is the father of Luna Lovegood and the editor of the *Quibbler* magazine, touted as the alternative voice for the wizarding world. Rhys Ifans, who portrays Xenophilius, describes his character and that of his daughter, Luna, as "genuinely free spirits. It's a freedom that is irreverent, but human and kind."

Harry meets Xenophilius at the wedding of Bill Weasley and Fleur Delacour, where he notices him wearing a unique pendant—the sign of the Deathly Hallows, composed of a circle split by a line encased within a triangle. Xenophilius serves as an important source of information about these three legendary magical artifacts, which allow the possessor to become the "Master of Death." The circle is for the Resurrection Stone, which can bring back the dead. The triangle represents the Cloak of Invisibility. And the third Deathly Hallow is the Elder Wand, symbolized by the line.

The prop modeler for Xenophilius Lovegood's wand, Pierre Bohanna, says it "captured his eccentricities." It seems that everything about Xenophilius has a peculiar twist to it, from the curvature of his cylindrical house to his wand, which twists like a unicorn horn, twirling with carvings of runic symbols along its length.

NEWT SCAMANDER

Magizoologist Newt Scamander has a deep respect for the beasts he studies and the environments in which they live in the Fantastic Beasts films, and so when it came time for actor Eddie Redmayne to select a wand for his character, he knew Newt wouldn't have a "flashy" one. "He's a humble guy," says Redmayne. "I wanted [his wand] to be quite simple. [W]e decided to have the wand be made out of ashwood, and it has quite a few scratches and sort of burn marks—so that you could get the sense that he's been traveling the world with it."[1]

Redmayne was also concerned that there be no animal products used in the wand, as he felt Newt would be sensitive to that. "So, the handle is belemnite," says concept artist Molly Sole. "That's a fossil, an ancient squid, which we thought was quite appropriate for him." The handle was created in a tubular form, like a sandworm shell, with a pearling effect at the top. The shaft is made from limewood.

In *Fantastic Beasts and Where to Find Them*, the Thunderbird Newt has rescued, Frank, becomes excited upon seeing Newt and creates a rainstorm with his wings. For this scene, Redmayne came up with the idea to use his wand as an umbrella against the shower. The ability to use a wand to shield a wizard against the elements is used again when Queenie Goldstein says goodbye to Jacob Kowalski under an Obliviating downpour produced by Frank.

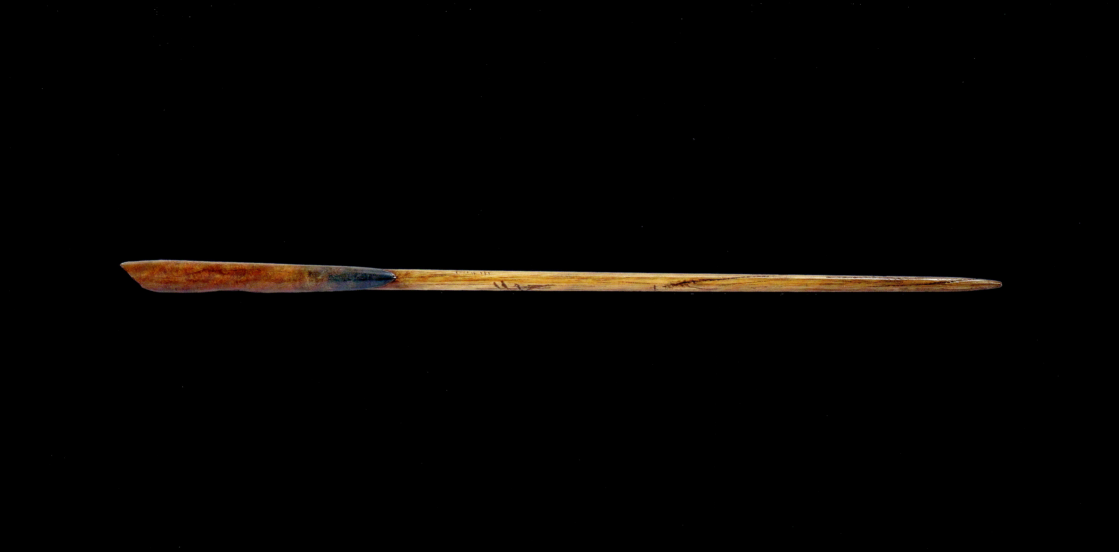

BUNTY BROADACRE

Bunty Broadacre assists Newt Scamander, taking care of the beasts he shelters in the magically enhanced basement of his London home, among other tasks. Newt's right-hand woman is first seen in *Fantastic Beasts: The Crimes of Grindelwald*. "Even though obviously she's completely in love with him," says actress Victoria Yeates, "she is very practical and probably keeps the show on the road, to be honest . . . [She's] a really dependable, trustworthy person."

Yeates is not surprised her character chose this particular vocation. "Her surname is Broadacre," she says, "so she definitely grew up on a farm. It's a very, kind of old English farm name. To be able to do what she does, she has that very strong side to her." She continues, "She spends hours and hours each day looking after terrifying animals. And has to wrangle them. So there is a strength to her. She's very loving and giving, but there's something very solid and stable about her that I think animals would trust."

Concept artist Molly Sole kept Bunty's character in mind while designing her wand, wanting it to feel humble and homey. "Bunty is this really sweet character who's obsessed with animals and in touch with nature," says Sole, "so I thought a fir cone would make a really nice handle and put a design of little ivy leaves wrapping around the wood."

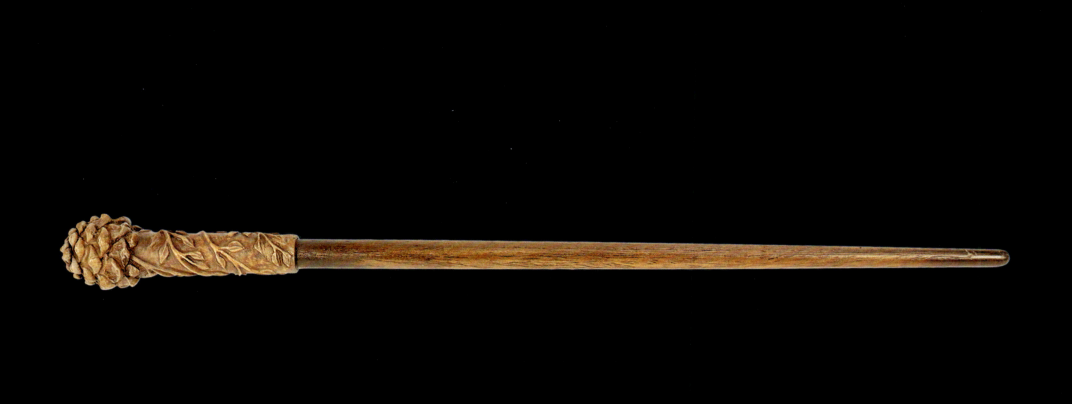

PROFESSOR HICKS

Professor Eulalie "Lally" Hicks is the Charms professor and Keeper of Keys at Ilvermorny School of Witchcraft and Wizardry in North America at the same time Newt Scamander is working with Albus Dumbledore against Gellert Grindelwald. Having corresponded with Dumbledore for years, she is a staunch ally, and he brings her in to help stop Grindelwald's anti-Muggle agenda and campaign for head of the International Confederation of Wizards.

Hicks is portrayed by Jessica Williams, who loves her character's independence and sense of humor. "Lally is very forthright, she's very moral, and she's always walking on the forward foot," says Williams. "She's also sly and witty, a real jokester." This witch is also Muggle-born, Williams says, so "she has a perspective of the [nonmagical] world; she straddles the line between that and the magical world."

Hicks's wand has a full head and torso as its handle that is a representation of an African goddess, carved in African rosewood, with the shaft made from a light ebony wood. "The wand is just beautiful," says Williams, who always wanted a wand. "It's just the coolest thing."

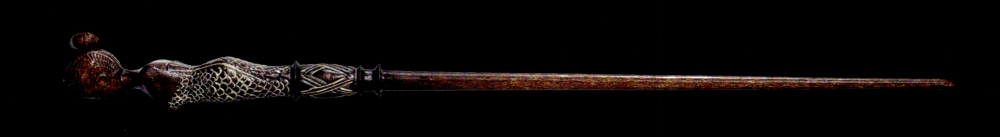

ABERFORTH DUMBLEDORE

Aberforth Dumbledore is the younger brother of Hogwarts Headmaster Albus Dumbledore and father to Credence Barebone, née Aurelius. Aberforth runs the Hog's Head tavern in Hogsmeade and is a member of the Order of the Phoenix, though his relationship with his brother is a tempestuous one. "I knew that there's a lot of history and trauma in the Dumbledore family," says Richard Coyle, who portrays Aberforth in *Fantastic Beasts: The Secrets of Dumbledore*, "so it was intriguing to be able to learn a little more and invest more into that really fascinating family relationship and dynamic."

Coyle was also aware of the way Aberforth was seen in the Harry Potter films: "When we meet Aberforth again, many years later in *Harry Potter and the Deathly Hallows – Part 2*, it's not like he's suddenly become really jovial and generous. He's still a bit of a grouch and he's giving Harry Potter a hard time. I felt a responsibility to that future."

The shaft of Aberforth's wand tapers down to its point. A section of turned wood that features thin and thick beading separates the shaft from a handle sporting a roughly hammered surface.

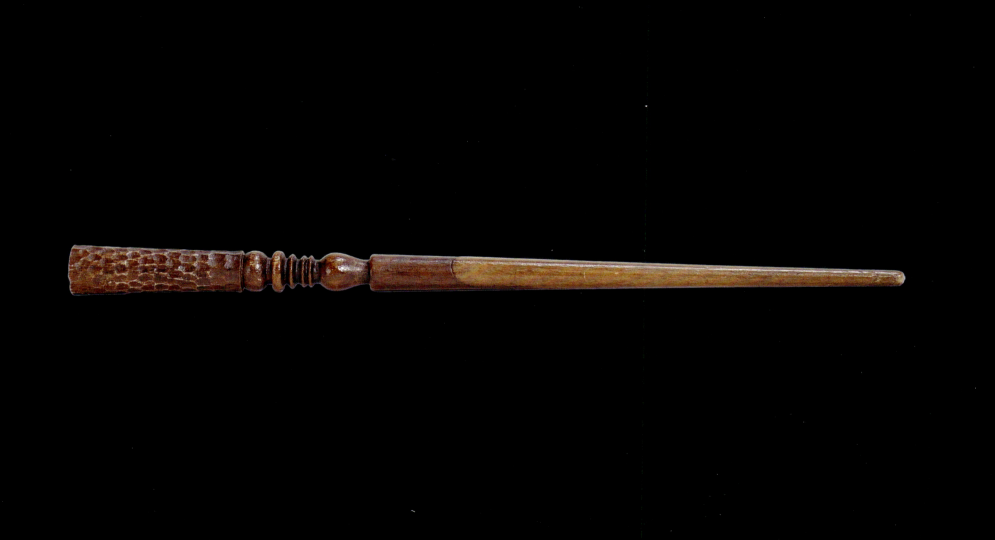

NICOLAS FLAMEL

Nicolas Flamel is more than 550 years old at the time of *Fantastic Beasts: The Crimes of Grindelwald*, and the only known maker of the Sorcerer's Stone, which grants its user immortality, among its other powers. Flamel is played by Brontis Jodorowsky, who is much younger.

When Flamel recognizes he must help Newt Scamander and his friends in their battle against Gellert Grindelwald at the Lestrange Mausoleum in Paris, Jodorowsky imagined that Flamel would need to look for his wand, as it had probably been a long time since he'd used it. Flamel is vital to creating the spell that stops Grindelwald's demonic fire.

For the design of Flamel's ancient-looking wand, concept artist Molly Sole was inspired by a very old horse whip with a bone end that her mother had collected. "I always thought it would make a really fantastic wand handle," says Sole. The wand has a faux-bone handle with a gold metal joiner that connects to a mahogany wood shaft. Jodorowsky describes the piece above the joiner as looking like a "dragon claw."

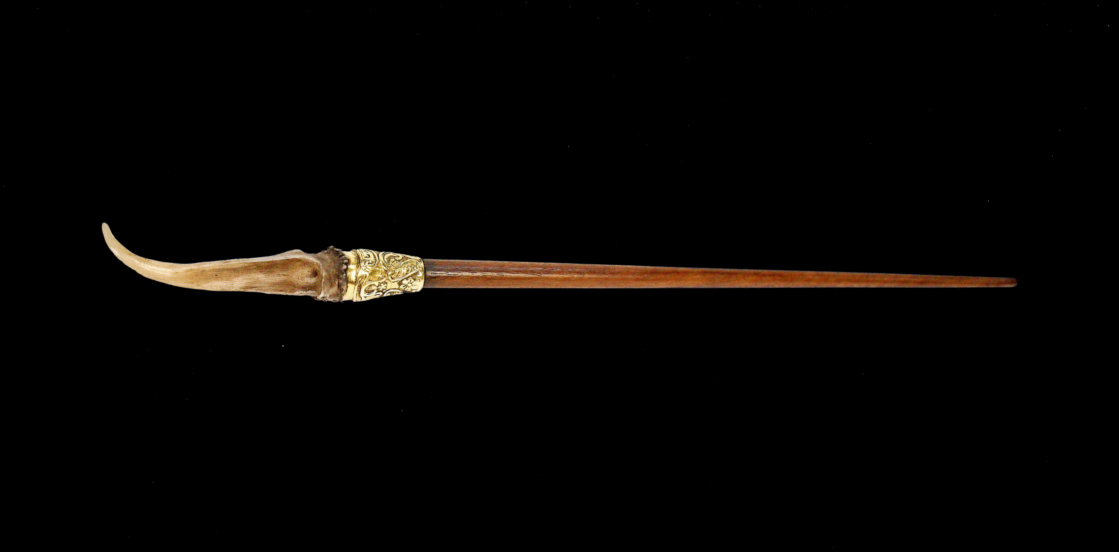

YUSUF KAMA

Yusuf Kama is a wizard seeking vengeance on behalf of his father, and his quest to accomplish this merges with that of Newt Scamander in *Fantastic Beasts: The Crimes of Grindelwald*: both are looking for Credence Barebone.

Kama is portrayed by William Nadylam, who suggests that "when you use a wand, when you use a spell . . . you're actually expressing deep emotions. And when we use magic, it's generally when human beings are overwhelmed, when they know that whatever task they have to accomplish is beyond their control. And whether it's to make it rain, or to find a cure for something, or to feel happy when you're down, that's when magic steps in."

Kama's wand has an ebony handle capped by a silver band; a silver cuff holds the shaft. A line called a quirk divides the handle into two sections. The shaft is made from partridgewood.

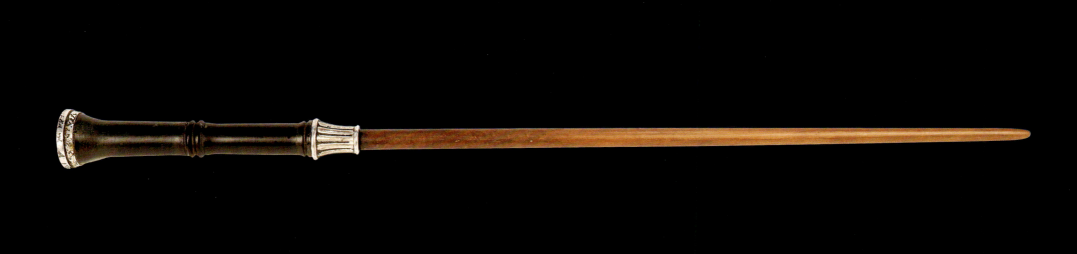

VINDA ROSIER

Vinda Rosier, played by Poppy Corby-Tuech, is Gellert Grindelwald's silent but devoted acolyte, assisting him as he gathers followers in *Fantastic Beasts: The Crimes of Grindelwald* and in his bid to become head of the wizarding world in *Fantastic Beasts: The Secrets of Dumbledore*. "In a word, she's fanatical," says Corby-Tuech. "It's almost bigger than Grindelwald. She's a believer, she's hardcore."

Corby-Tuech confirms that the day she got her wand was one of the most exciting days of her work on *The Crimes of Grindelwald*. "And we've all got our own technique," she says of the assortment of acolytes Grindelwald gathers around himself. "We were practicing [together] and it's interesting how everyone has their own wand style." She describes her own way of wand work as "gentle."

As Rosier does not speak much, Corby-Tuech knew that her character would come from her body language and movement, which is evoked in the sinuous lines of her wand. The wand flows in one continuous line of dark wood turned with beads, rings, and long, stretched "reels" divided by quirk lines.

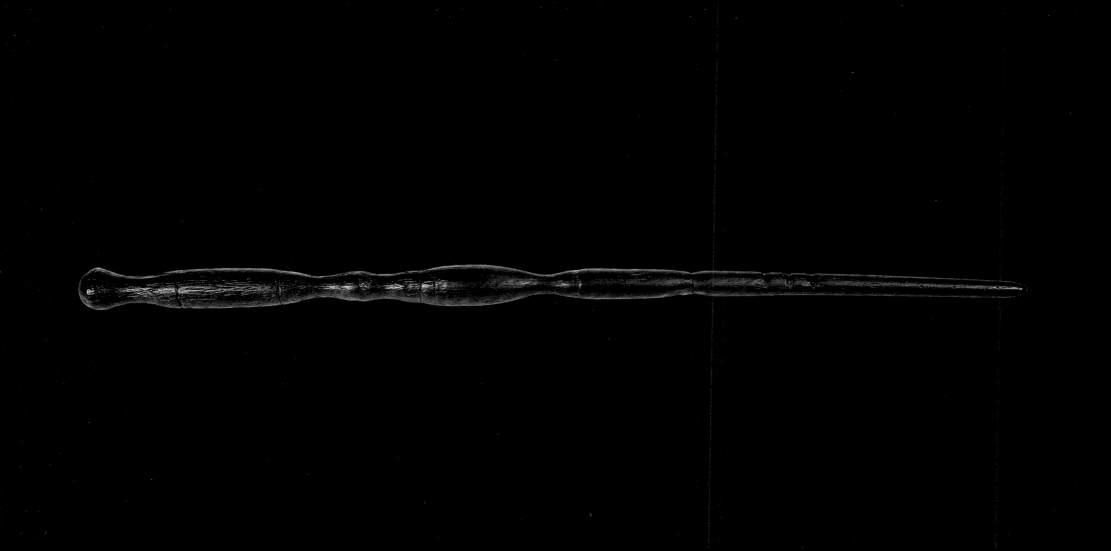

CREDENCE BAREBONE

For Credence Barebone's appearance in *Fantastic Beasts and Where to Find Them*, actor Ezra Miller describes their character, an Obscurial, as "just too powerful for a wand," and as a big Harry Potter fan, Miller was "bummed!" ("I wanted a wand.")

When Credence falls under the influence of Grindelwald in *Fantastic Beasts: The Crimes of Grindelwald*, he is gifted a wand by the older wizard, which he uses in *Fantastic Beasts: The Secrets of Dumbledore*. "Now there's an ability to concentrate and focus the Obscurial magic he possesses," says Miller, "but it is a dark, destructive form. His magic is incredibly strong but incredibly limited, though now he has the capacity to direct it intentionally."

Credence's wand is made of a sleek, black ebony wood, with a six-sided, flat, faceted knob at the tip of its handle. In *Secrets of Dumbledore*, Credence has a wand duel with his uncle, Albus Dumbledore. "That was honestly one of the most exciting and incredibly cool experiences," says Miller. "It's a very beautiful duel; a moment where there's really explosive action, but it's motivated by something that's happening on a very small, human, heart-based level."

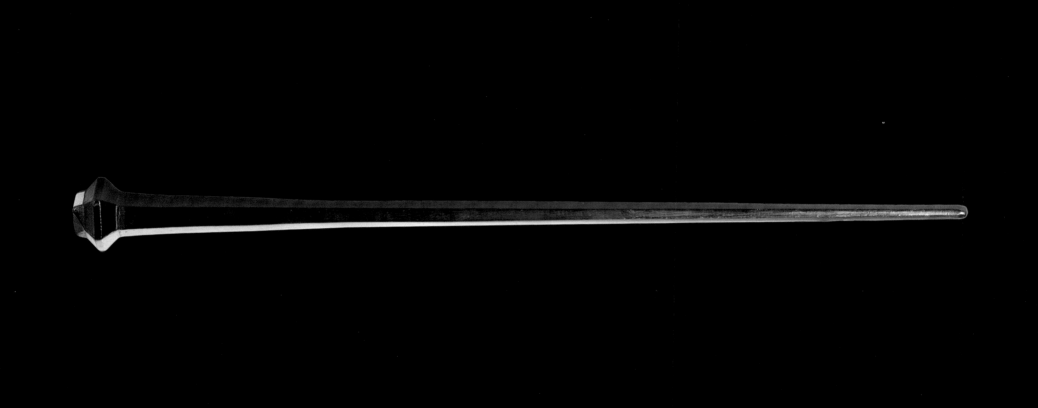

LORD VOLDEMORT

Tom Riddle, a half-blood wizard and member of Slytherin house at Hogwarts, became obsessed with the Dark Arts and a desire to achieve immortality while still a youth. He eventually abandoned his Muggle-born identity and took on the name Lord Voldemort. He is considered by many to be the most dangerous and powerful wizard in the wizarding world.

In *Harry Potter and the Order of the Phoenix*, choreographer Paul Harris developed specific wand movements for the powerful exchanges between Voldemort and Dumbledore during their battle in the Ministry. Their first move in the duel is what Harris calls the "Rope of Fire." "I used this action, which is a dance movement called a rope spin. It's normally done with a girl," Harris laughs, "but in this case, it's a wand with some fire coming out of the end of it."

Voldemort's wand is perhaps the most menacing created for the films. It appears to be carved from a single—perhaps human—bone, with a honeycombed midsection and a polished tip. The crook of a knuckle joint offers Voldemort the perfect place to hook his finger as he so delicately balances the wand above his head. "It's quite an evil shape," says concept artist Adam Brockbank.

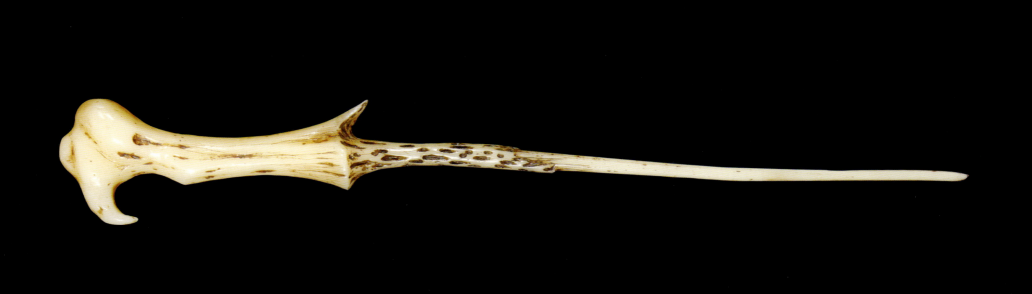

BELLATRIX LESTRANGE

Bellatrix Lestrange is a loyal Death Eater who escapes in a mass breakout from Azkaban prison in *Harry Potter and the Order of the Phoenix*.

Bellatrix is vicious with her wand, and she is responsible for the Cruciatus Curse cast on Neville Longbottom's parents prior to the story's events, as well as the murder of Sirius Black when she casts *Avada Kedavra* in the notorious duel in the Veil Room during the battle in the Department of Mysteries.

"I definitely have the best wand, don't I?" says actress Helena Bonham Carter. "My wand is warped. It sort of looks like another talon, like an extension of my manicure."

The wand features a gently curved handle inscribed with ancient runic symbols, but the tip appears to be honed from a massive bird of prey, with its sharp, clawlike shape. Featuring a dragon heartstring core, the walnut wand is described as "unyielding" by Ollivander in *Harry Potter and the Deathly Hallows – Part 2*.

"I think she liked it because it's almost like a witch's finger," says prop maker Pierre Bohanna. "It starts with a handle that's got a little bit of rune decoration, but then it moves into almost like a fingertip, with a forty-five-degree angled curve."

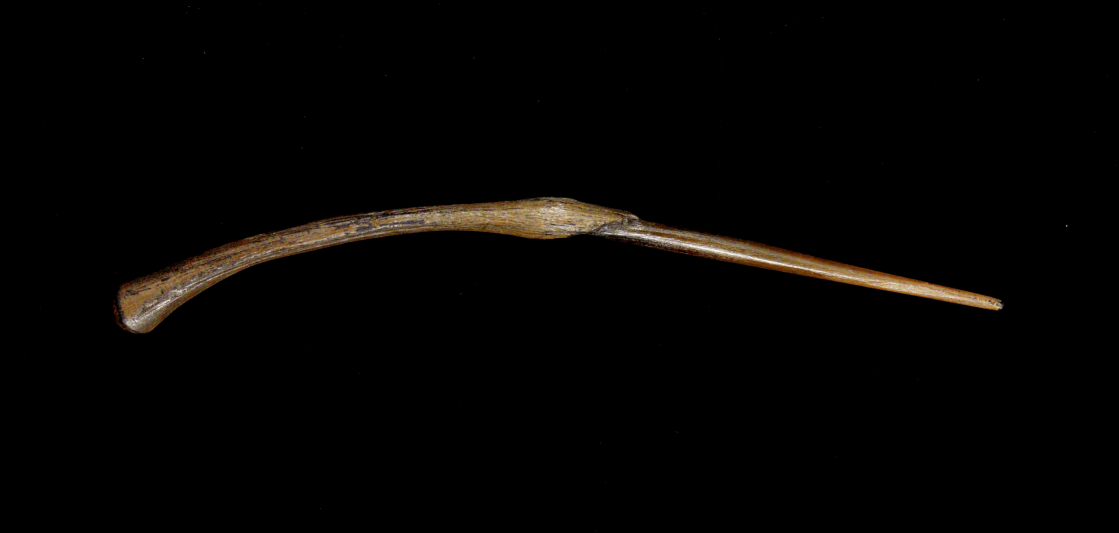

PETER PETTIGREW

Peter Pettigrew, an Animagus better known by his moniker, "Wormtail," is responsible for tipping off the Dark Lord to the whereabouts of Harry Potter and his parents, leading to the deaths of James and Lily Potter. Pettigrew is portrayed by actor Timothy Spall.

The original casting for Peter Pettigrew's wand was carved from a dowel of ebony wood, says prop modeler Pierre Bohanna. The design is that of a snake coiling inward on itself, with its coiled head creating the handle and its tail serving as the tip of the wand. "The wand is supposed to be an extension of your character," says concept artist Adam Brockbank. "It must have been an interesting moment for each actor when they first picked up their wand."

Pettigrew casts one of the Unforgivable Curses in the Little Hangleton graveyard after the final Triwizard Tournament challenge in *Harry Potter and the Goblet of Fire*, when he does Lord Voldemort's bidding and casts the Killing Curse, *Avada Kedavra*, murdering Cedric Diggory.

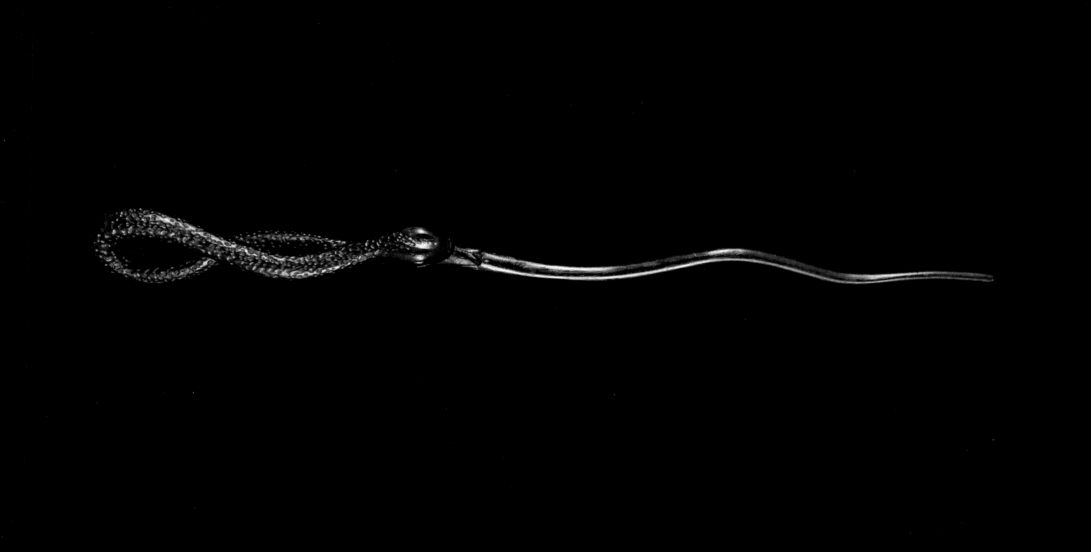

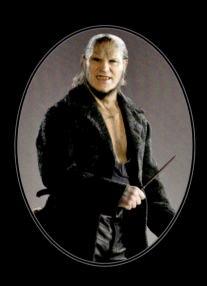

FENRIR GREYBACK

Fenrir Greyback is a vicious werewolf who has allied with Death Eaters and is responsible for infecting Remus Lupin with lycanthropy. Actor Dave Legeno describes his character as "a mercenary" for "using Voldemort to feed him new victims." Legeno felt that if it wasn't for Greyback being cursed, "he would have been a happy, decent, productive man, but it all went wrong, and he's going to make everyone pay. He's probably more evil than Voldemort, in a way, because he is a man, and he doesn't have to be as horrible as he is."

Fenrir's surprisingly elegant wand is a black-and-brown-mottled wood with a handle marked by a newel-post top and a wooden ring with silver bands. The shaft is thick and comes to a rounded point at the tip.

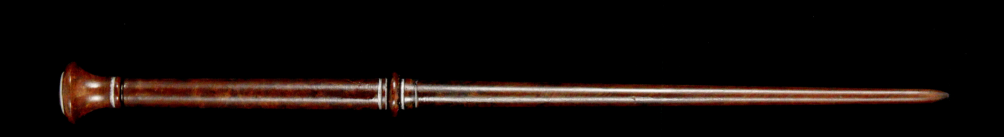

ANTONIN DOLOHOV

One of the Death Eaters who escapes in the mass breakout from Azkaban prison in *Harry Potter and the Order of the Phoenix*, Antonin Dolohov duels alongside Lucius Malfoy against Sirius Black and Harry Potter in the Battle of the Department of Mysteries.

In *Harry Potter and the Deathly Hallows – Part 1*, after tracking Harry, Hermione, and Ron to a Muggle café on Tottenham Court Road, Dolohov and fellow Death Eater Thorfinn Rowle enter dressed as Muggle workmen and attempt to catch the trio off guard with a surprise attack. The following skirmish is brief, ending with Hermione hitting Dolohov with a Full Body-Bind Curse and Obliviating both Death Eaters. In the final film, Dolohov, played by Arben Bajraktaraj, participates in the Battle of Hogwarts.

Antonin Dolohov's wand features a long, spiral-carved, rough-hewn handle that snakes into a dramatic hook-shaped curve adorned with a skull at its top. The shaft itself shifts from a light to a darker shade in an ombré-type flow.

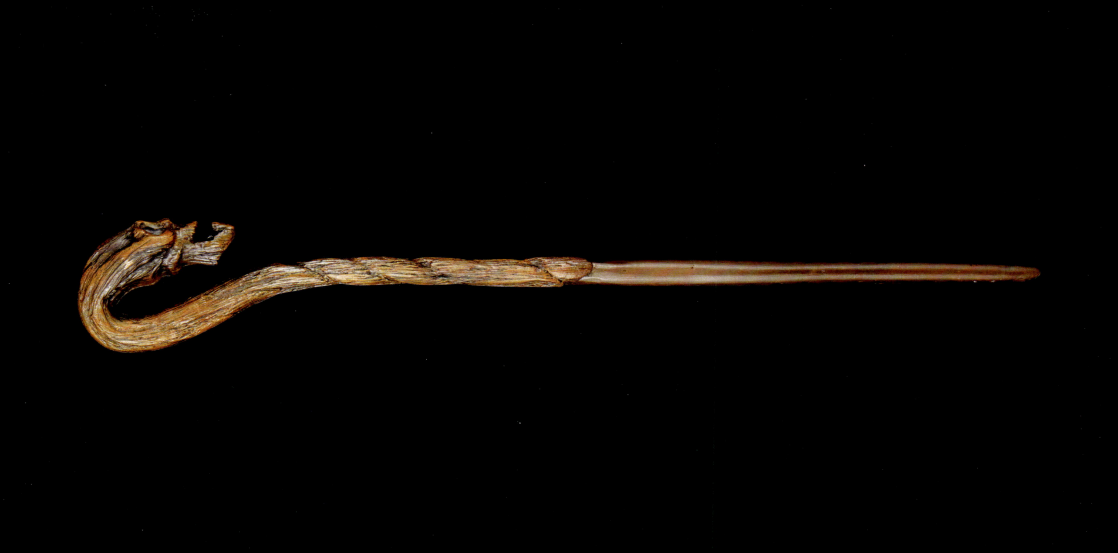

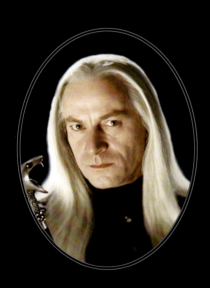

LUCIUS MALFOY

When cast as the Death Eater Lucius Malfoy, Draco's father, actor Jason Isaacs asked director Chris Columbus if his character could have a cane. Columbus asked, "Why, is there something wrong with your leg?" Isaacs replied, "No, I just think it would be good for pointing and gesturing, and I could pull a wand out of it." So it was that Lucius's walking stick with its concealed wand became incorporated into his costume for the Harry Potter films. Isaacs confesses he thinks his is the coolest wand in the wizarding world and that it makes his character Lucius Malfoy walk a bit taller.

Lucius is a known practitioner of the Dark Arts with his wand, including Unforgivable Curses. He attempts to perform the Killing Curse on Harry in *Harry Potter and the Chamber of Secrets*, but his once-enslaved house elf Dobby interferes and repels him.

The handle of Lucius's wand, a silver, fang-bearing snake head, gleams with emerald gems—the color of Slytherin—for its eyes. The wand itself is simple and straight, made from a dark, unblemished wood.

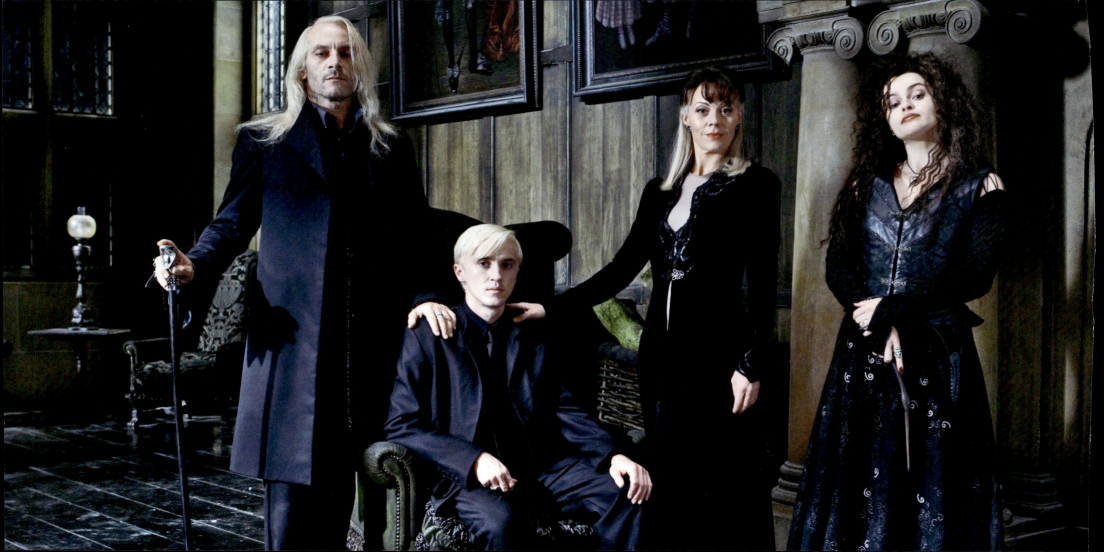

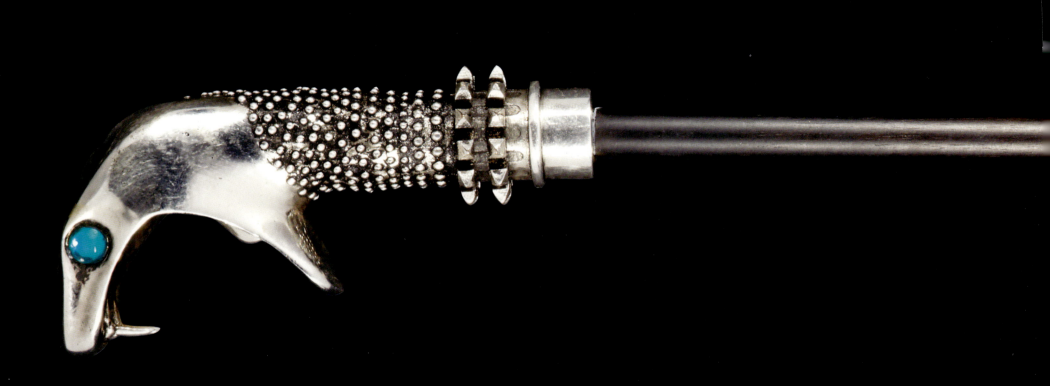

NARCISSA MALFOY

Narcissa Malfoy is the sister of Bellatrix Lestrange and the wife of Lucius Malfoy, but first and foremost, she is a mother to Draco. "She's somebody who puts her children before her[self] first," says actress Helen McCrory. "She might be a baddie, but she's a good mother."

Narcissa's wand is fashioned of the same wood as her husband's. Silver bands and studs adorn the ebony handle, which finishes in a pyramidal tip, adding a dangerous touch to the Malfoy family style of elegance and sophistication. "Narcissa is a pure-blood, and in the world of Harry Potter, an aristocrat," says McCrory. For Narcissa, designer Adam Brockbank strove to create a feminine version of her husband's wand. "And then I embedded silver studs into the black wood of her wand," he explains. Prop modeler Pierre Bohanna feels that these wands effectively represent their wizards: "It's all presentation with the Malfoys. It's all to do with how you look rather than what the purpose is."

Narcissa gives her wand to her son, Draco, when his is taken by Harry Potter in *Harry Potter and the Deathly Hallows – Part 2*.

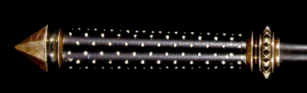

ALECTO CARROW

Death Eater Alecto Carrow, portrayed by Suzie Toase, serves as Deputy Headmistress of Hogwarts and Muggle Studies professor under Headmaster Severus Snape in *Harry Potter and the Deathly Hallows – Part 1* and *Part 2*. Alecto and her sibling, Amycus, are rabid supporters of Voldemort and find important positions at the school, as seen in *Harry Potter and the Deathly Hallows – Part 2*. "Snape has turned Hogwarts into a pretty grim place," says director David Yates. "And he's got two horrible Death Eaters, the Carrows, as 'teachers.' There's a state of lockdown and it feels as if all the magic's gone."

The topper of Alecto's wand is decorated with a toothless, open-mouthed human skull, which leads into a handle resembling a spinal cord. The wand's shaft is made up of a dark and uneven wood.

Carrow's reputation landed her on the Ministry's Most Wanted list.

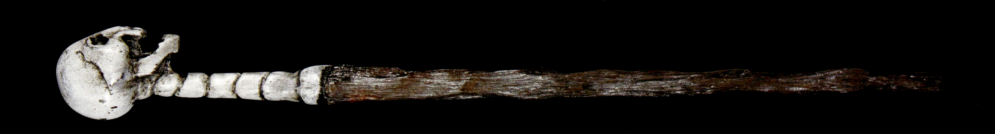

AMYCUS CARROW

Brother of Alecto Carrow, Amycus is a Death Eater and known associate of Lord Voldemort, described by actor Ralph Ineson as his "loyal puppet." He is present at Professor Dumbledore's death atop the Astronomy Tower in *Harry Potter and the Half-Blood Prince*, and later takes the post of Defense Against the Dark Arts professor while Severus Snape is Headmaster. Ineson describes it as being "a rather plum job, although we go fairly early in *Part 2*. We die just before Snape escapes to join Voldemort!" Indeed, during Snape's duel with Professor McGonagall in the Great Hall in *Harry Potter and the Deathly Hallows – Part 2*, Amycus and Alecto are hit by spells deflected backward by the former Potions professor.

Amycus Carrow's long, elaborate wand features a serpentine shape carved with scales. Its handle curves into the face of a snake at its top and features a small, ivory-white skeleton just below the snake's mouth.

CORBAN YAXLEY

Corban Yaxley is a Death Eater who evaded imprisonment in Azkaban.

Peter Mullan, who plays Yaxley, was in the final scene shot on the last day of filming of the Harry Potter films, which appears in *Harry Potter and the Deathly Hallows – Part 1.* He shoots a silver flash out of his wand at Hermione, Ron, and Harry as they attempt to escape from the Ministry of Magic. It is Ron's *Expelliarmus* spell that disarms Yaxley and safeguards their getaway.

Yaxley's wand is economical, with sharp, flattened edges for newels and carved rings in its handle. A single silver band featuring trios of metal beads on its six sides adorns its black length.

SCABIOR

The wizard Scabior, played by Nick Moran, leads a group of Snatchers who capture Harry, Ron, and Hermione in *Harry Potter and the Deathly Hallows – Part 1* following a chase in the Forest of Dean.

When Scabior brings the trio to Malfoy Manor, he and the other Snatchers are assaulted by Bellatrix Lestrange, who lashes out at them upon recognizing the Sword of Gryffindor. Scabior is disarmed in the skirmish and loses possession of his wand. Later, fighting alongside Lord Voldemort in the Battle of Hogwarts, Scabior appears briefly on-screen with a different wand.

Scabior's first wand is jet black and jagged, as if formed from a piece of obsidian glass. Its many nicks and worn-down areas suggest it has seen a lot of use and rough handling.

CORNELIUS FUDGE

The Minister for Magic at the British Ministry during Harry Potter's time at Hogwarts is Cornelius Fudge, who struggles with Harry's claim—often failing to believe it—that the Dark Lord Voldemort has returned to take over the wizarding community. Actor Robert Hardy felt that Fudge was more about personal advancement and political recognition than taking care of his community's needs, and that this inevitably led to his downfall and disgrace for making the wrong choices.

Fudge uses a notable wand at the 422nd Quidditch World Cup in *Harry Potter and the Goblet of Fire* to cast the *Sonorus* spell to broadcast his voice through the stadium as he opens the game. The wand features two white, matching sphere shapes intricately carved with a style of latticework. However, by the time of filming *Harry Potter and the Order of the Phoenix*, he's associated with a different wand. The latter wand features a twisted handle, much like the "barley" style wand of Arthur Weasley. However, where Weasley's wand maintains a rich, consistent color throughout the wood, Fudge's wand has two distinct tones, with the handle a lighter hue than the shaft.

RUFUS SCRIMGEOUR

A renowned and courageous fighter against the Dark Arts, Rufus Scrimgeour serves as the Minister for Magic during the dark times of Lord Voldemort's return, succeeding Cornelius Fudge. Actor Bill Nighy, who portrays Scrimgeour, describes his character as authoritative but with good intentions: "He's a soldier who has a new role, but one for which he may not be entirely fitted."

In *Harry Potter and the Deathly Hallows – Part 1*, this Minister is tasked with revealing the bequeathments made to Harry, Ron, and Hermione by the late Albus Dumbledore. "I come not only to deliver their inheritance, but to find out their significance," says Nighy. "I'm not so confused by the fact that he left something for Harry, but I wish to know what meaning these particular articles have!"

Scrimgeour bears the formidable wand of a former Auror, made from a heavy mahogany-colored hardwood. It is elegant and just; two weighted beads form the top of the flared handle, which is separated from the wand's shaft by a ringed silver band.

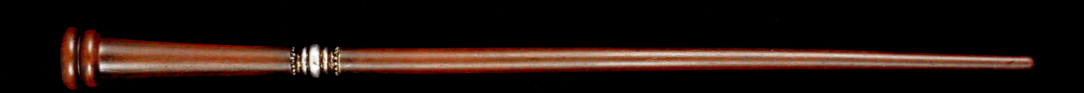

PIUS THICKNESSE

Instated as Minister for Magic in *Harry Potter and the Deathly Hallows – Part 1* after the death of Rufus Scrimgeour, Pius Thicknesse, portrayed by Guy Henry, is key to the Death Eaters' infiltration of the Ministry of Magic. "What say you, Pius?" says Voldemort, during a meeting with his followers at Malfoy Manor, about rumors that Death Eaters have infiltrated the Ministry. "One hears many things, my Lord," Pius replies cautiously. "Whether the truth is among them is not clear." "Spoken like a true politician," notes the Dark Lord. "You will, I think, prove most useful, Pius."

In *Harry Potter and the Deathly Hallows – Part 2*, Pius dons Death Eater robes during the Battle of Hogwarts, where he is killed not by the opposing forces but by Voldemort himself. Frustrated by Pius's continued questioning, Voldemort punishes him with the Killing Curse.

Pius Thicknesse's wand features a thick but elegantly curved spindle on its handle, which is set between two ornamented silver rings.

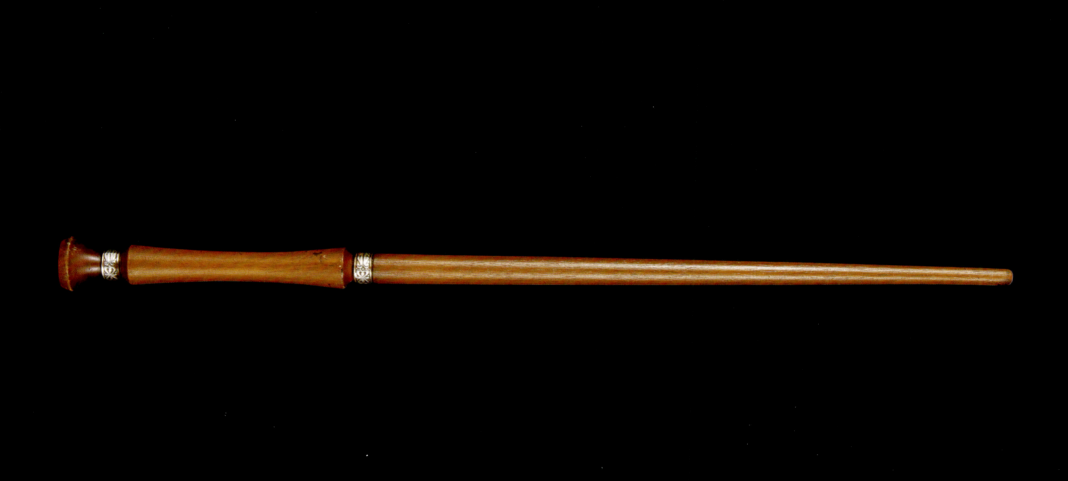

THESEUS SCAMANDER

In the early 1930s, the head of the British Ministry of Magic's Auror Office is Theseus Scamander, older brother of Magizoologist Newt Scamander. Theseus and Newt have a difficult relationship—though they are both fighting against Grindelwald, Newt is part of the rebellion, while Theseus is part of the establishment. But by working together, they realize their differences make them stronger.

Theseus is played by Callum Turner, who describes his early experiences with his wand in *Fantastic Beasts: The Crimes of Grindelwald* as "volatile." "I actually broke it on the first outing," he says. "But, it is amazing. You can do everything and anything." Turner attended wand school prior to filming, where he realized that his initial physical actions with the wand were "a bit too much. If you're very good at it," he explains, "you don't have to put too much effort in."

The Auror's wand has a short tortoiseshell handle that designer Molly Sole thought "would be really rather elegant for a chap who would do well for themselves in the future." A brass collar separates the handle from the shaft.

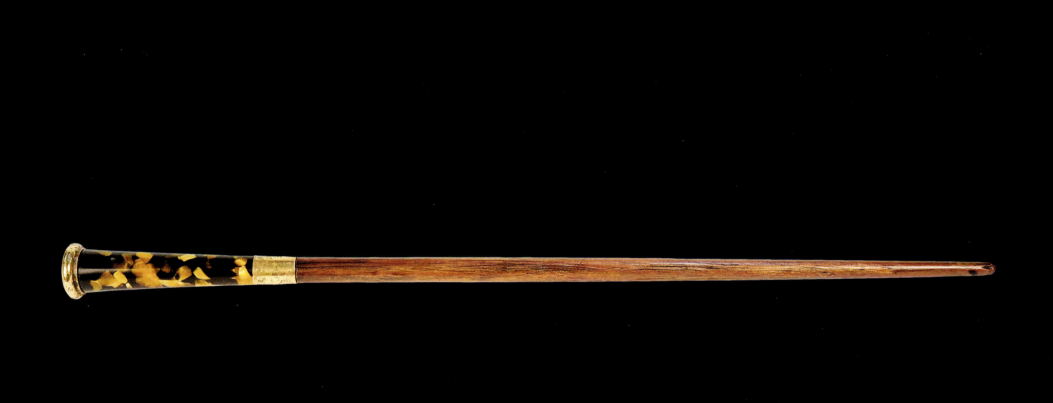

LETA LESTRANGE

Leta Lestrange works for the British Ministry of Magic in the late 1920s as an assistant in the Department of Magical Law Enforcement. She was once close friends with Newt Scamander. Later, she is engaged to his brother, Theseus. She is murdered by Gellert Grindelwald while trying to save her friends.

"Leta has a secret that unravels during the course of *Fantastic Beasts: The Crimes of Grindelwald*," says actress Zoë Kravitz. Though Leta has done bad things in her life, "she isn't quite sure where she fits in in terms of being good or bad. She's somewhere in between," Kravitz adds. "She's quite complicated."

Leta's wand combines the dark tone of ebony wood with the bright shine of silver. "Leta has a strong pure-blood family background," says designer Molly Sole, "and we wanted the wand to reflect that level of prestige. It had to look rich and commanding." The handle consists entirely of twists, bordered on each side by long silver collars featuring filigree similar to Mogul arabesque patterns. Kravitz felt her wand was very appropriate for Leta. "It's a very fancy wand," she laughs.

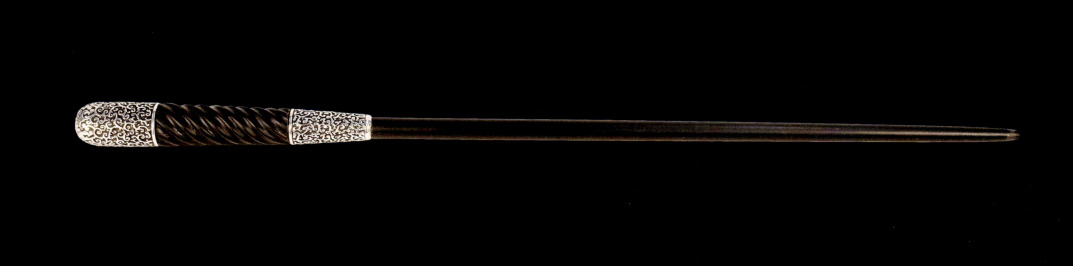

TINA GOLDSTEIN

Porpentina "Tina" Goldstein is an Auror for the Magical Congress of the United States of America in North America. In *Fantastic Beasts and Where to Find Them*, however, Tina is temporarily working in MACUSA's Wand Permit Office with her sister, Queenie. "Tina has real skill as an Auror," says actress Katherine Waterston, "but unfortunately, she doesn't always handle situations as well as she hopes to."

"What wand would choose Tina?" the actress asked herself. Waterston viewed several different kinds of wands, which, to her, told different stories. "If a really ornate wand chooses you . . . are you going to become a really important witch?" she asks. "Or if you have a really basic wand, [do] you think, 'Oh, I'm not going to achieve greatness'?" Waterston admits having fun making her selection. "At that point, I was so far into it, it was so obvious what wand would be right for me. But I did ask for it to be heavier. It just didn't feel powerful enough."

Tina's wand is a conductor-style piece made from a dark brown wood. "Tina's wand is more functional, more understated," says designer Molly Sole. "[Director] David [Yates] didn't want it to be too jazzy because that wouldn't suit Tina."

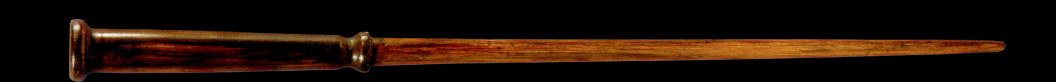

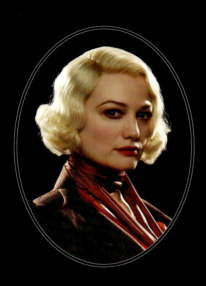

QUEENIE GOLDSTEIN

Queenie Goldstein, Tina's sister, works in MACUSA's Wand Permit Office. She is also a Legilimens. "She has the ability to read minds," explains actress Alison Sudol. "She's a magical empath, so even though she's able to do magic with her wand, a lot of her magic is internal, which makes her a different type of wizard or witch."

Queenie's wand has a design at the top of the handle evoking a piece of mother-of-pearl that is sculpted into a snail shell shape. A gold collar with an Art Deco design separates the handle from the very simple shaft made out of dark rosewood. "Alison did have a little bit of influence on hers because she really likes Art Deco," says concept designer Molly Sole. "We put her taste in that and it really helped us get the time period into the design."

"What I love about Queenie's wand is something that I love about her, which is that there is a great deal of beauty in it, but it's simple as well," adds Sudol. "It's elegant. It has a lovely weight at the end but it's very delicate at the tip. The minute I picked it up, I thought, 'Oh, there we go, that works.'"

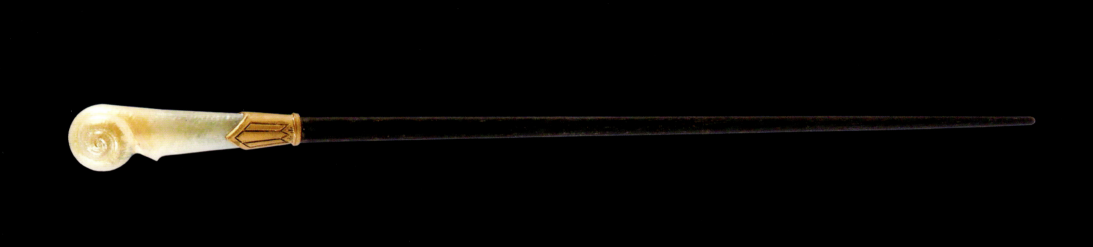

PERCIVAL GRAVES

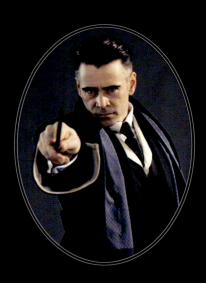

In 1929 New York City, Auror Percival Graves is the Director of Magical Security and Head of the Department of Magical Law Enforcement for MACUSA. But unknown to his coworkers at the North American wizarding government offices, Graves's identity has been usurped by the Dark wizard Gellert Grindelwald in *Fantastic Beasts and Where to Find Them*.

Actor Colin Farrell, who plays Graves, describes himself as being "absolutely giddy" when he received his wand, despite the fact that the filmmakers would be casting the magic. After a wand movement, Farrell says, "[I know] nothing is going to happen. And then somebody will come in and make something happen, and that will look cool!"

Graves's sleek, ebony wand is fairly straightforward, evoking a walking stick. The handle and shaft are separated by a silver bifurcated band. Another silver embellishment, in a very simple Art Deco style, caps the tip.

To the discerning eye, however, Graves is noticeably skilled at wandless charms and spells, as shown when he appropriates Newt Scamander's suitcase at MACUSA or moves the caged Obscurial through the air using only hand gestures. This might be a clue as to the real amount of power at play, which is actually Grindelwald's.

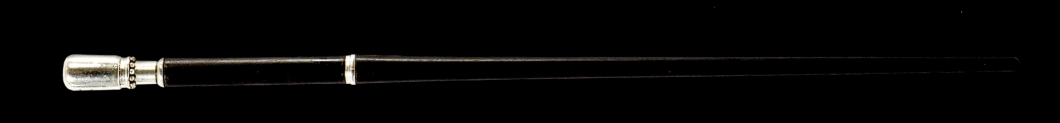

SERAPHINA PICQUERY

The president of MACUSA in 1929 is Seraphina Picquery, who must deal with attacks on New York City by an unknown magical entity. The North American wizarding community lives in secrecy, so this rampant destruction in the city threatens to expose the magical world in *Fantastic Beasts and Where to Find Them*. Picquery is further tasked by the beasts that have escaped Newt Scamander's case, which also threaten the magical status quo.

Actress Carmen Ejogo says her character is "epic. She is passionate and committed to the community, and her objective, ultimately, is to keep everyone safe." Picquery is powerful in her appearance, as she is in her authority, although Ejogo maintains that she isn't ostentatious in any way. "But," Ejogo says, "I do think she is commanding, and she knows the power that she yields. Her wand, for example, represents that power. You can tell that something epic will happen when it's used."

Picquery's wand has a pink-jeweled handle, which head prop maker Pierre Bohanna describes as "quite simple and quite classic." The design is influenced by the Art Deco style of the time period. The shaft is ebony, with a detailed silver clasp separating it from the handle.

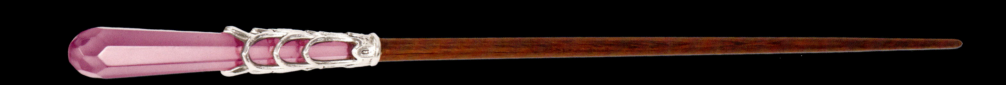

ANTON VOGEL

Anton Vogel is the German Minister for Magic who, in 1932, is ending his term as the Supreme Mugwump of the International Confederation of Wizards. There are two official candidates for the position—Liu Tao and Vincência Santos—but Vogel supports a third, Gellert Grindelwald, and acquits him of his crimes so Grindelwald can run.

Oliver Masucci, who portrays Vogel in *Fantastic Beasts: The Secrets of Dumbledore*, feels Vogel is worried that if he doesn't let Grindelwald enter, "people will riot on the street and cause a revolution, so he lets him stand."

Masucci admits it was fun coming into the film series as an established leader. "You're not coming as an underdog," he says. "But my time is over."

Vogel's wand has a dark wooden shaft with raised lines that taper to the end. Its handle has an Art Deco–style design with a combination of silver and gold, giving it a sleek look.

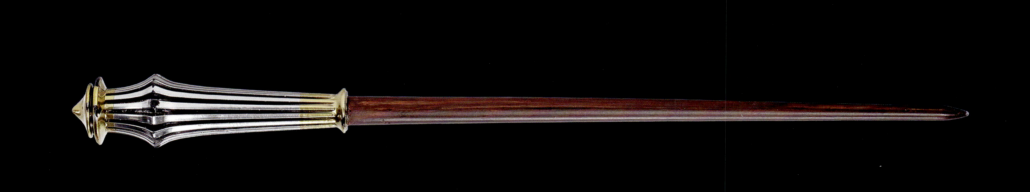

LIU TAO

Liu Tao is an ally of those against Gellert Grindelwald—his name is listed in the book Nicolas Flamel uses to contact other wizards when Dumbledore cannot be found—in *Fantastic Beasts: The Crimes of Grindelwald*.[2] Tao, played by actor Dave Wong, is the Chinese Minister for Magic during the events of *Fantastic Beasts: The Secrets of Dumbledore*. In 1932, he is one of three candidates to become the Supreme Mugwump of the International Confederation of Wizards. This post is chosen by the Qilin—an ethereal, deerlike beast who can evaluate the true goodness and strength of personality in a candidate's soul to determine their fitness to rule. Although Tao most certainly has a better moral code than candidate Gellert Grindelwald, the Qilin chooses the Brazilian Minister for Magic, Vincência Santos.

Tao's wand has a light wood shaft that is separated into three sections by a trio of silver rings. The ebony wood handle has seven twists and a flat end cap.

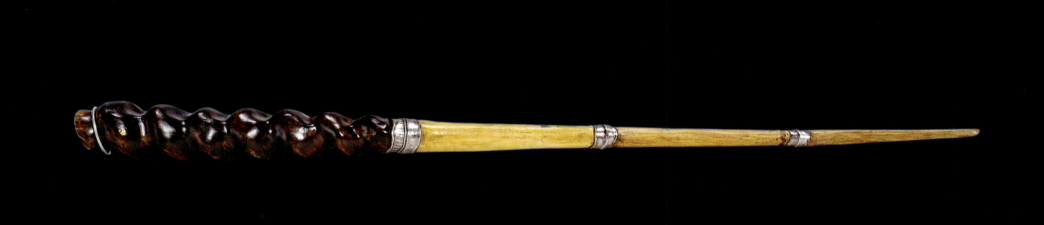

VINCÊNCIA SANTOS

Vincência Santos, played by actress Maria Fernanda Cândido, is the Brazilian Minister for Magic. She becomes a candidate for Supreme Mugwump of the International Confederation of Wizards in 1932 and is eventually chosen by the Qilin for the post after Albus Dumbledore declines.

Cândido believes that Santos intends to create a new way of governance if she wins the election. "Less judgment, less competition, more caring, more love," says Cândido. "She thinks we must learn how to live with our differences. And, above all, stop using those differences to find age-old ways of keeping other people down."

The handle of Santos's wand features a black-and-white design that resembles the intricate pattern of a woven basket. The wand's shaft has been sanded down to expose the grain of its wood. When Gellert Grindelwald casts the Cruciatus Curse upon the Muggle Jacob Kowalski at the Ceremony of the Qilin, it is Santos who removes the curse and relieves his agony.

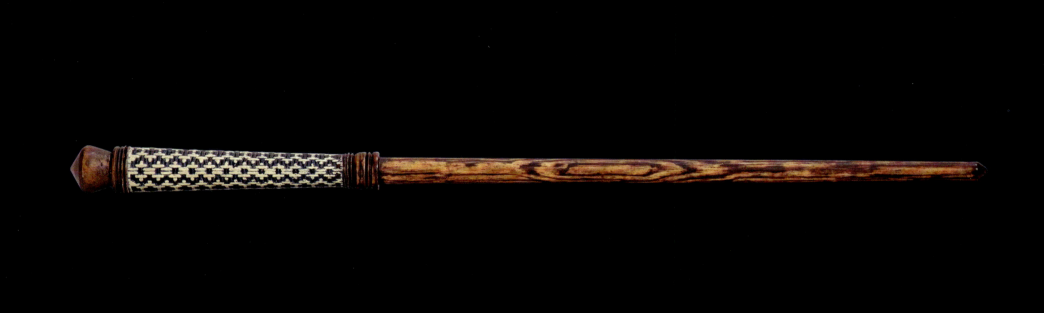

HENRIETTA FISCHER

Henrietta Fischer is an attaché of Anton Vogel, the German Minister for Magic, as seen in *Fantastic Beasts: The Secrets of Dumbledore*. Fischer, portrayed by Valerie Pachner, has questionable loyalties.

Prior to the Ceremony of the Qilin in Bhutan, Fischer tells Newt Scamander that she has been given instructions by Dumbledore to take him up to the Eyrie, but when Newt becomes suspicious of her, she forcibly takes the case he is carrying. Fischer believes the second, pure Qilin is being brought to the ceremony in that case. After the first Qilin chooses Grindelwald, Fischer allows him to open the case, and to their surprise, it disintegrates.

Fischer's wand is made from a dark wood. The top and bottom of the handle are fitted with silver caps. In between these are nine wooden beads in a cove shape, separated by thin silver bands.

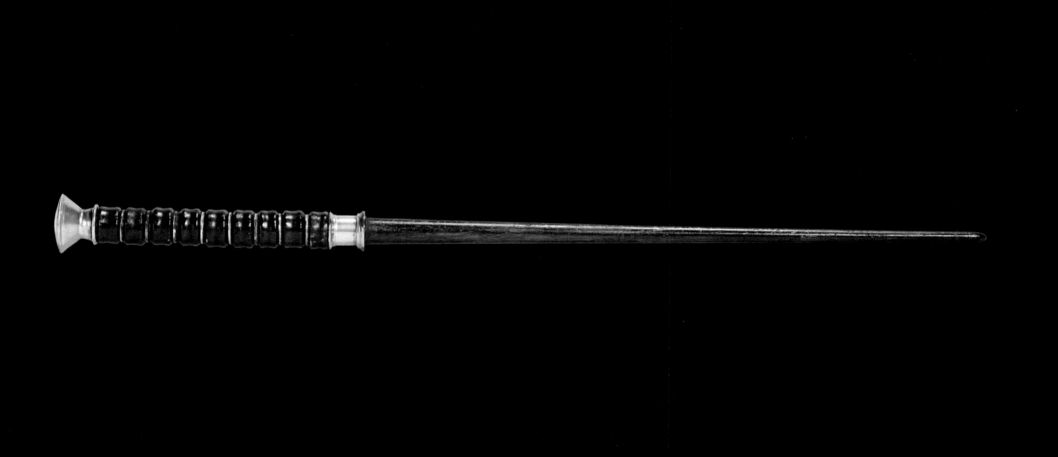

JACOB KOWALSKI

Jacob Kowalski, a nonmagical Brooklyn baker, finds himself entangled in the wizarding world when he accidentally exchanges identical cases with Newt Scamander in *Fantastic Beasts and Where to Find Them*. When he sees the incredible beasts Newt has rescued and what magic can do, as when Queenie Goldstein assembles an apple strudel with a wave of her wand, he is besotted. "I wish I was a wizard," he sighs.

In *Fantastic Beasts: The Secrets of Dumbledore*, Jacob gets a gift from Albus Dumbledore he never thought possible: "I finally get a wand!" declares actor Dan Fogler. "It felt so good to have something there in the breast pocket, where he keeps it." Jacob has no formal wand training, but as he served in World War I, "he holds his wand like a gun."

Jacob's wand is made from snakewood, a rarely used wood for wands. "The top has been whittled to have a funky knob and the rest is like a windy branch," Fogler describes. "It was so cool!" However, the wand has no core, and therefore Jacob cannot cast any spells. "But the wand is wonderfully distressed," says prop maker Pierre Bohanna, "and has this dashing snake-end to it. It's supposed to be very rough-hewn and rather rubbish. But he obviously loves it."

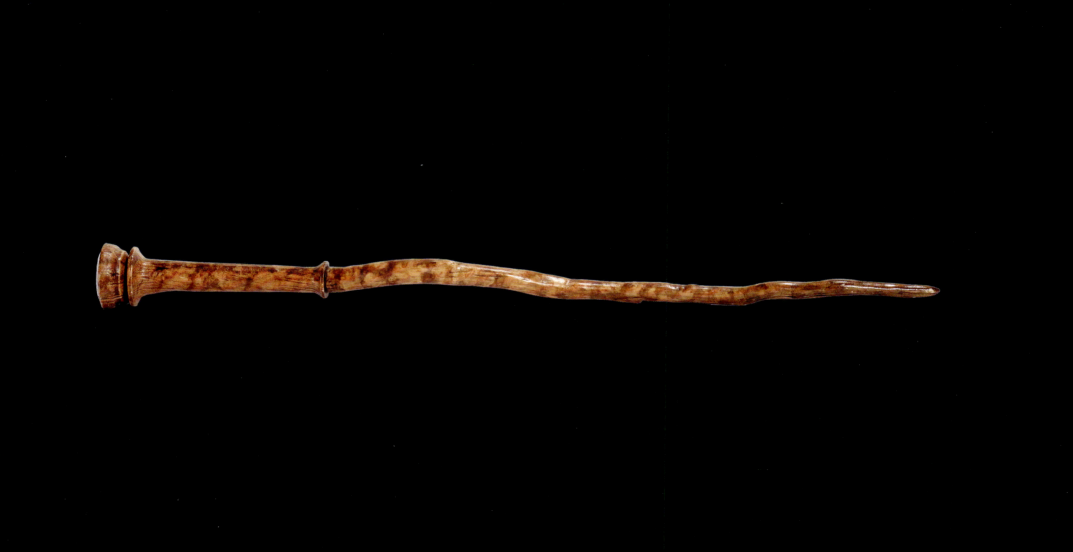

THE ELDER WAND

"'The oldest asked for a wand more powerful than any in existence. So, Death fashioned him one from an Elder tree that stood nearby.'"
—Hermione, reading from *"The Tale of the Three Brothers"* in *The Tales of the Beedle the Bard, Harry Potter and the Deathly Hallows – Part 1*

During the events of the Harry Potter films, Albus Dumbledore wields the Elder Wand—the most powerful wand in existence. But before Dumbledore defeats its master in a duel, the wand is in the possession of Gellert Grindelwald. As explained in *Harry Potter and the Deathly Hallows – Part 1*, in his youth, Grindelwald stunned the wandmaker Mykew Gregorovitch and then stole the Elder Wand from him.

When Dumbledore's wand was created for *Harry Potter and the Sorcerer's Stone*, it was not known that this wand would have such importance. But fortunately, the design of the wand was easy to recognize from a distance. "And it should be," says prop modeler Pierre Bohanna. "As far as wands are concerned, it's the one to beat all others."

The Elder Wand was fashioned from English oak. "What makes it very recognizable," Bohanna continues, "is that not only is it one of the thinnest wands, it has these wonderful outcroppings of nodules on it, every two or three inches." The wand is also inlaid with a faux-bone material inscribed with runes.

After Dumbledore's death, the Dark Lord Voldemort takes the wand from his tomb, but is never its true master, because it is Draco Malfoy who has disarmed the Headmaster. The wand changes its allegiance once again, to Harry Potter, after he defeats Draco and takes his wand. Harry, upon realizing that he is now the holder of all three Deathly Hallows, chooses to destroy the Elder Wand to break its power over life and death.

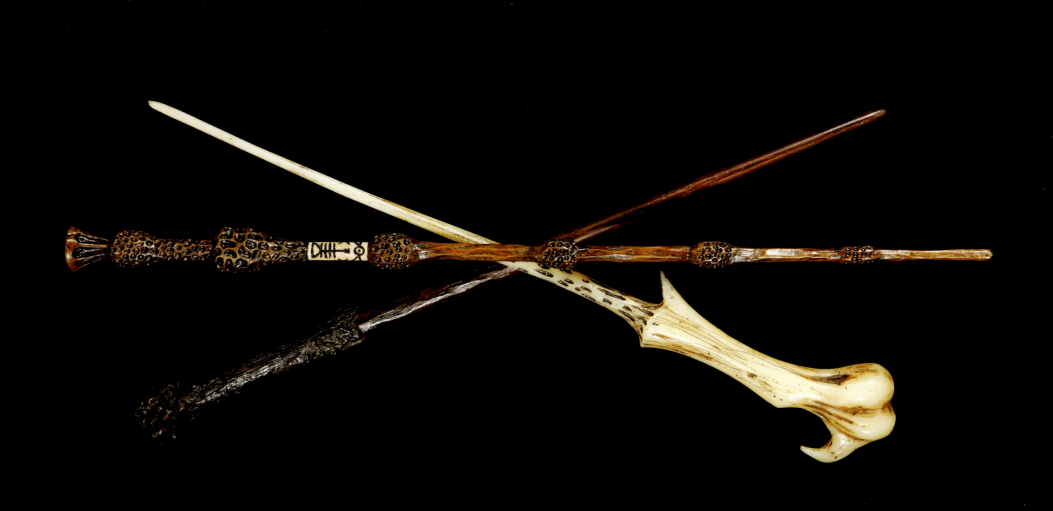

Conclusion

"You want magic to be real in life," says David Thewlis, who plays Professor Remus Lupin in the Harry Potter films. What is substantial about the Harry Potter films is that they touch on something slightly sinister—a darker side to life and death—and therefore something real. "And," says Thewlis, "you want to be able to beat your enemies with a wand or with a thought or with something that's just simply not possible in real life." There is a reason why we love this wizarding world so much. We experience it with every aim of the wand. Thewlis calls it "hope."

Wand Index

Harry Potter • **14 inches**

Ron Weasley (First Wand) • **14.25 inches**

Ron Weasley • **13.5 inches**

Ron Weasley (Second Wand) • **13.75 inches**

Hermione Granger • **13.25 inches**

Neville Longbottom • **13.5 inches**

Fred Weasley • **13.5 inches**

George Weasley • **14 inches**

Ginny Weasley • **14 inches**

Draco Malfoy • **13.5 inches**

Luna Lovegood (First Wand) • **14.75 inches**

Luna Lovegood (Second Wand) • **13.5 inches**

Dean Thomas • **14.25 inches**

Seamus Finnigan • **13 inches**

Vincent Crabbe • **15 inches**

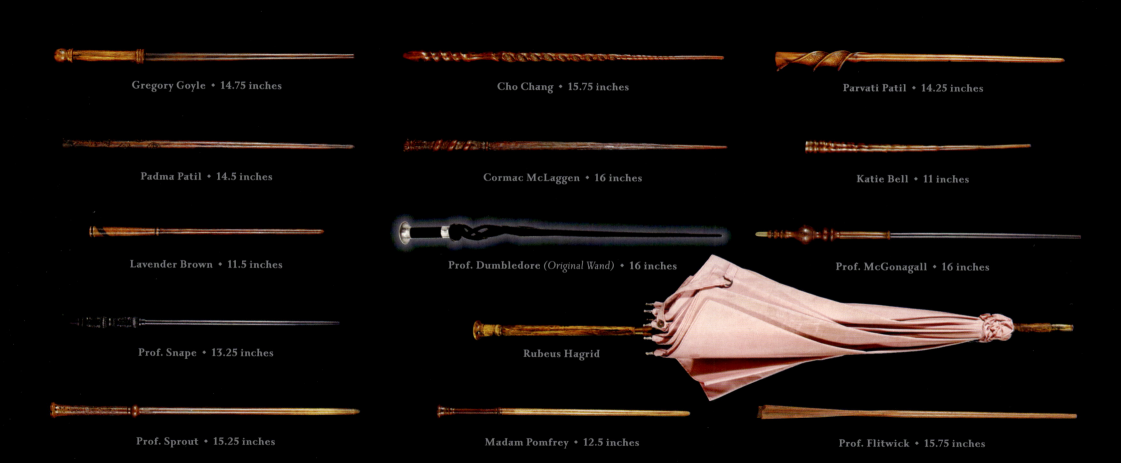

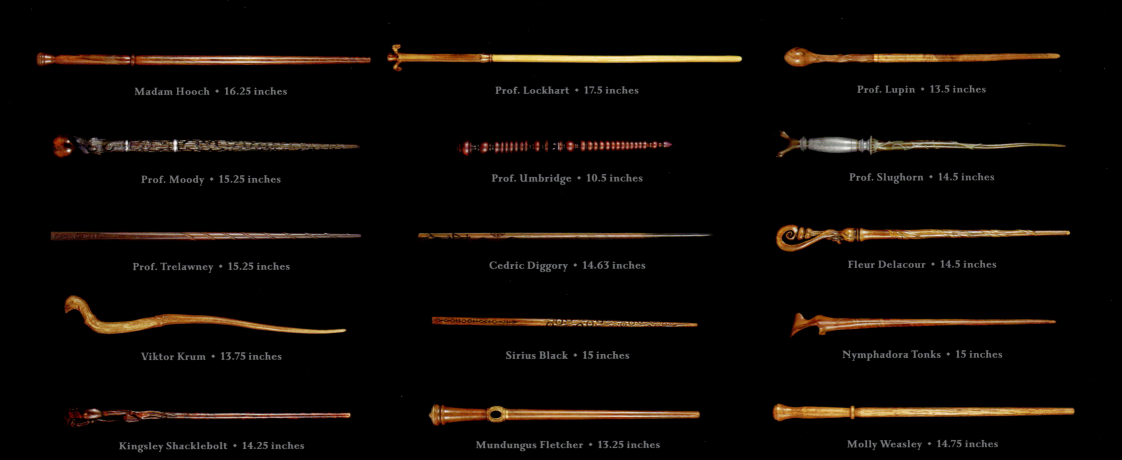

Arthur Weasley • 16 inches

Garrick Ollivander • 14.5 inches

Xenophilius Lovegood • 15 inches

Newt Scamander • Not recorded

Bunty Broadacre • Not recorded

Professor Hicks • 14 inches

Aberforth Dumbledore • 13.5 inches

Nicolas Flamel • Not recorded

Yusuf Kama • Not recorded

Vinda Rosier • Not recorded

Credence Barebone • 14 inches

Lord Voldemort • 14.25 inches

Bellatrix Lestrange • 14 inches

Peter Pettigrew • 14.25 inches

Fenrir Greyback • 14 inches

Antonin Dolohov • 14.25 inches

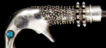
Lucius Malfoy • 17.25 inches

Narcissa Malfoy • 12.25 inches

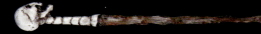
Alecto Carrow • 14 inches

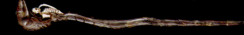
Amycus Carrow • 14 inches

Corban Yaxley • 15.75 inches

Scabior • 14.75 inches

Cornelius Fudge • 16 inches

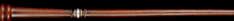
Rufus Scrimgeour • 15.25 inches

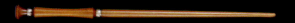
Pius Thicknesse • 15 inches

Theseus Scamander • Not recorded

Leta Lestrange • Not recorded

Tina Goldstein • Not recorded

Queenie Goldstein • Not recorded

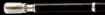
Percival Graves • Not recorded

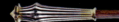
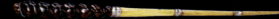

Seraphina Picquery • 14 inches Anton Vogel • Not recorded Liu Tao • Not recorded

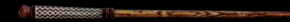
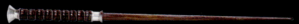
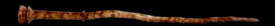

Vincência Santos • Not recorded Henrietta Fischer • Not recorded Jacob Kowalski • 13.5 inches

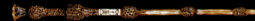

The Elder Wand • 16 inches

Footnotes

1. http://ew.com/article/2016/08/02/fantastic-beasts-eddie-redmayne-wand/

2. https://static.wikia.nocookie.net/harrypotter/images/1/15/Tao_in_Flamels_Phoenix_book.jpg/revision/latest/scale-to-width-down/1000?cb=20210602053709

PO Box 3088
San Rafael, CA 94912
www.insighteditions.com

Find us on Facebook: www.facebook.com/InsightEditions
Follow us on Instagram: @insighteditions

Copyright © 2024 Warner Bros. Entertainment Inc. WIZARDING WORLD characters, names, and related indicia are © & ™ Warner Bros. Entertainment Inc. WB SHIELD: TM & © WBEI. Publishing Rights © JKR. (s24)

All rights reserved. Published by Insight Editions, San Rafael, California, in 2024.

No part of this book may be reproduced in any form without written permission from the publisher.

ISBN: 979-8-88663-114-2

Publisher: Raoul Goff
VP, Co-Publisher: Vanessa Lopez
VP, Creative: Chrissy Kwasnik
VP, Manufacturing: Alix Nicholaeff
VP, Group Managing Editor: Vicki Jaeger
Publishing Director: Jamie Thompson
Designer: Lola Villanueva
Editor: Joanna Botelho
Editorial Assistant: Sami Alvarado
Managing Editor: Maria Spano
Senior Editor: Michael Hylton
Senior Production Manager: Greg Steffen
Senior Production Manager, Subsidiary Rights: Lina s Palma-Temena

Insight Editions, in association with Roots of Peace, will plant two trees for each tree used in the manufacturing of this book. Roots of Peace is an internationally renowned humanitarian organization dedicated to eradicating land mines worldwide and converting war-torn lands into productive farms and wildlife habitats. Roots of Peace will plant two million fruit and nut trees in Afghanistan and provide farmers there with the skills and support necessary for sustainable land use.

Manufactured in China by Insight Editions

10 9 8 7 6 5 4 3 2 1